WOKING
THROUGH TIME
Marion Field

AMBERLEY PUBLISHING

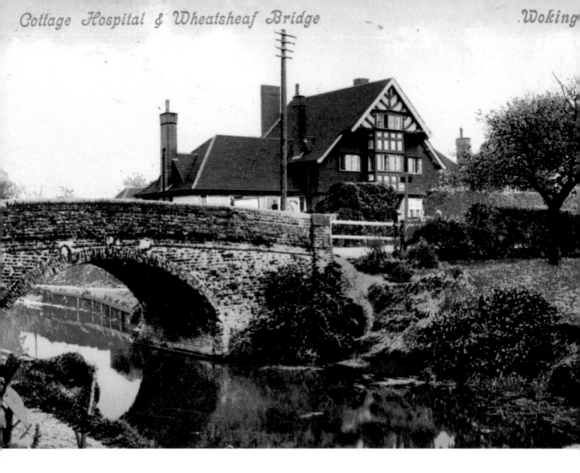

Cottage Hospital & Wheatsheaf Bridge Woking

First published 2014

Amberley Publishing
The Hill, Stroud, Gloucestershire, GL5 4EP
www.amberley-books.com

Copyright © Marion Field, 2014

The right of Marion Field to be identified as the
Author of this work has been asserted in accordance with
the Copyrights, Designs and Patents Act 1988.

ISBN 978 1 4456 2118 0 (print)
ISBN 978 1 4456 2127 2 (ebook)

British Library Cataloguing in Publication Data.
A catalogue record for this book is available from the
British Library.

Typesetting by Amberley Publishing.
Printed in Great Britain.

Introduction

Wochingas, the Saxon name for Woking, appears in the Domesday Book of 1086. A flourishing congregation still worships regularly in St Peter's, the eleventh-century Norman church built on the site of an earlier Saxon one. The area surrounding the church is now known as 'Old' Woking to distinguish it from the nineteenth-century town.

'New' Woking owes its existence to the railway and the Brookwood cemetery. The railway came first. In 1834, Parliament passed an act authorizing the building of a railway from London to Southampton. By 1838, the first part of the railway from 'Nine Elms' – now Vauxhall – to 'Woking Common' had been built. In May of that year, a train carrying a number of VIPs travelled to Woking where its important passengers were treated to a luxurious lunch before starting their return journey. The railway line was extended and, in 1840, the Railway Hotel was built on the south side of the railway to accommodate the increasing number of passengers.

In the mid-nineteenth century, there was a cholera epidemic in London and the churchyards ran out of grave space. A new cemetery was urgently needed. What better place to establish it than Woking with its new railway line bordered by acres of common land? In 1851, the Necropolis Company was formed. It bought 2,000 acres of common land and, in spite of local opposition, used 400 acres to create a new cemetery in what is now known as Brookwood.

In 1857, over 4 acres of land on the southern side of the station was sold to a Mr John Raistrick, a wealthy railway contractor. After he died, his son George refused to sell any of the land for redevelopment. He is often blamed for the fact that Woking developed on the 'wrong' side of the station – the northern side! Until the twenty-first century the station's main entrance was on the south side!

In 1855, the land on this side was sold off by the Necropolis Company in sections so that there was no organized planning and the town developed in a haphazard fashion. In 1856, the Albion Hotel was built opposite the northern entrance to the station. It rivalled the Railway Hotel on the south side. By the end of the century, shops had been built in Chertsey Road and along the High Street, and houses had been built along Maybury Road and Walton Road. By this time, the population had grown to over 18,000.

Woking also boasted the first mosque to be built in England. This was in the grounds of the 'Oriental Institute', which had taken over a building that was originally built as a Royal Dramatic College for not only budding actors, but also for 'decaying (retired) actors and actresses'. A more

controversial erection was that of the first crematorium in St John. Created in 1879, the first human cremation was not until 1885 when cremation became legal.

During the twentieth century, Woking underwent many changes as some buildings were demolished, new ones built and 'New' Woking became a bustling town. Commuters to London continued to use the excellent train service but by the twenty-first century, others were using it to travel *from* London to work in Woking where new businesses frequently appear.

Woking is not a town to stand still. It now has an impressive arts centre containing a 2,000-seat theatre and six cinema screens. The Light Box with its restaurant and variety of exhibitions attracts many visitors. Woking also contains an excellent library, which has recently been renovated, and the very useful Surrey History Centre with its vast store of county archives is also situated in Woking.

There have been so many changes in the town over the twentieth and twenty-first centuries that it has become very difficult to identify the 'old' roads and sites of buildings. No doubt there will be yet more changes over the coming years.

Author's Note

Because of the changes in Woking over the years, I have sometimes found it difficult to identify the original sites of buildings. I can only therefore apologise for any errors I may have inadvertently made.

Marion Field

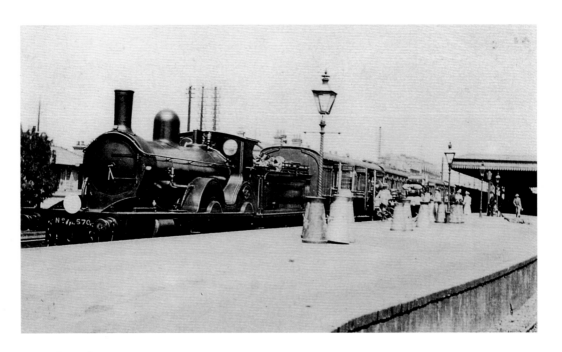

The Railway

Work began on the railway in October 1834 and by 1838, the line had been completed from Nine Elms, now Vauxhall, to Woking Common. On 12 May of that year, a group of VIPs left Nine Elms and travelled by train to Woking in just 45 minutes. On arrival, they were entertained to lunch before their return journey, which took only 43 minutes! Today, Woking still has an excellent train service. There are frequent trains to London and also trains to the West Country. Woking continues to grow as a result of the railway and more businesses are being established. At one time, the town was known as a commuter town. However, today, there are as many people travelling to Woking to work as there are travelling to London.

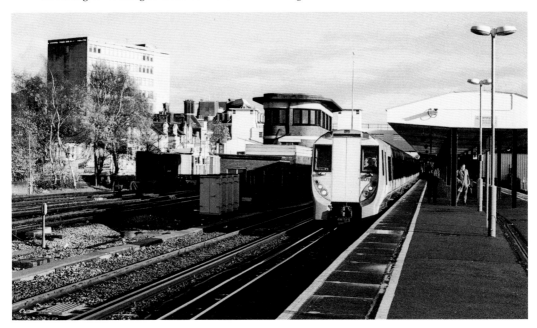

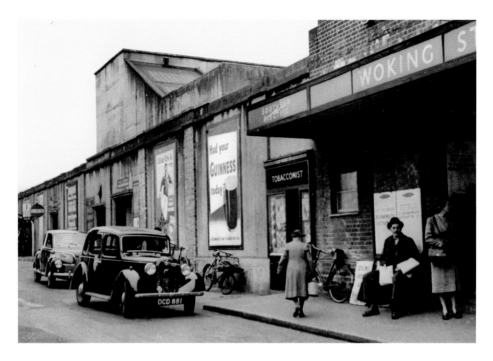

Woking Station

Originally 'New' Woking was supposed to develop on the southern side of the railway line, but George Raistrick, who owned the land, refused to sell it for redevelopment. Consequently, most of the building took place on the northern side and the 'main' station entrance faced the south. It was not until the twenty-first century that the station was redesigned and the main entrance is now on the northern or 'town' side of the railway line. Simultaneously, an impressive archway – much criticised by local residents – was built across the road to Albion House.

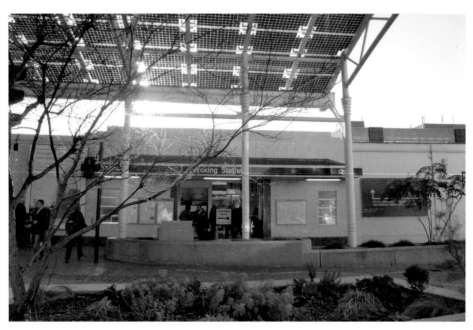

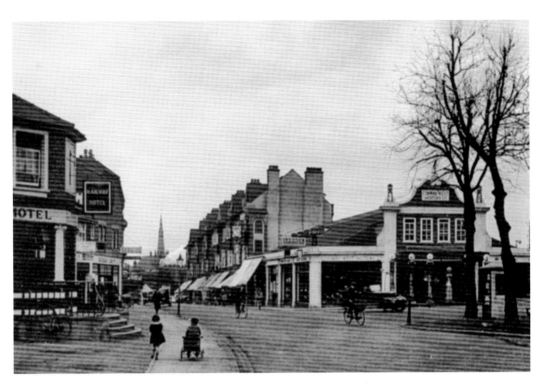

The Railway Hotel

The opening of the railway meant an increase in traffic and mail coaches travelling through Woking. The Railway Hotel in Guildford Road was built in 1840 to accommodate the increasing number of passengers. Stabling was also provided for their horses to rest while their owners travelled. The original building remains but has been renovated to accommodate today's visitors. It has had several owners but is now owned by the Ember group and has changed its name to 'The Sovereigns'. It is no longer a hotel but continues to serve traditional food, including an excellent Sunday roast. (*Photograph above: copyright of Surrey History Centre*)

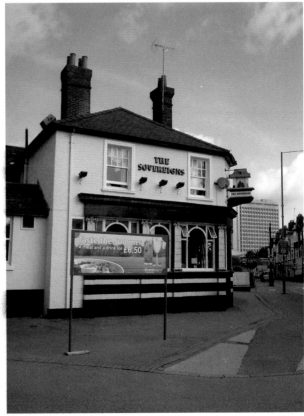

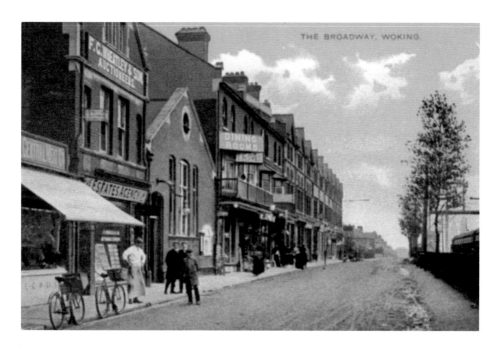

The Broadway

In the 1870s, 'New' Woking began to develop and shops appeared on the northern side of the railway station. The western end of Maybury Road was renamed The Broadway in 1923. For many years, Ashby's Bank (later Barclays) stood at the corner of Chertsey Road and The Broadway. The corner of The Broadway and Chertsey Road is now occupied by Budgens supermarket. During the twentieth century, a bus service developed and a number of bus stops were erected next to the railway line. Opposite the shops in The Broadway, buses serving the local community continue to ply their trade. (*Photograph above: copyright of Surrey History Centre*)

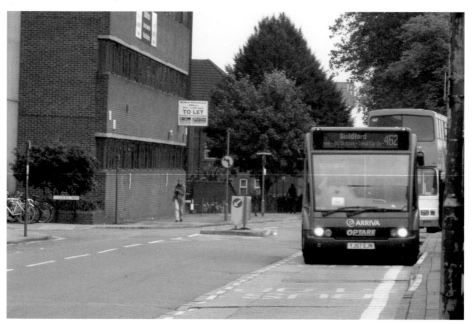

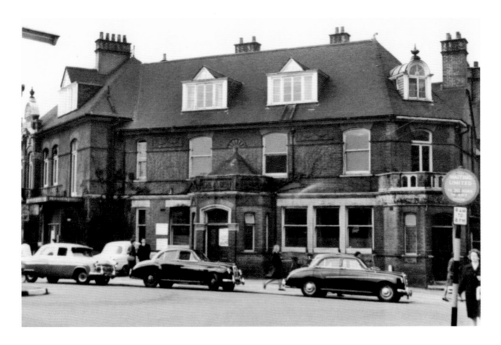

The Albion Hotel

In 1856, the landlord of the Wheat Sheaf Inn decided to build a second hotel, rivalling the Railway Hotel on the northern side of the railway, opposite the station. This flourished for a number of years as it was nearer the station than the Railway Hotel and more convenient for passengers. It was rebuilt in 1897. In the 1960s, Woking underwent a major redevelopment. The Albion Hotel was demolished in 1965. Several shops replaced the hotel but the name was retained and the section is now known as Albion House. The 'canopy', built later, stretches over to Albion House so passengers are briefly under cover.

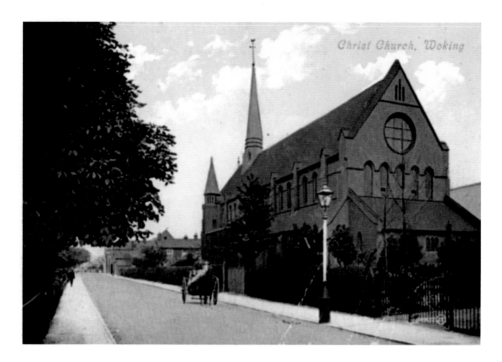

Christ Church

The foundation stone for the first church built in 'New' Woking was laid in November 1887. However, it was not until June 1893 that the consecration service was held in Christ Church at the corner of Church Path. The church has undergone several changes since its origin. Towards the end of the twentieth century, the pews were removed and replaced by chairs. Lunchtime organ recitals are often held. As the town church, it caters for the community with a variety of services. It also boasts a bookshop and a coffee shop.

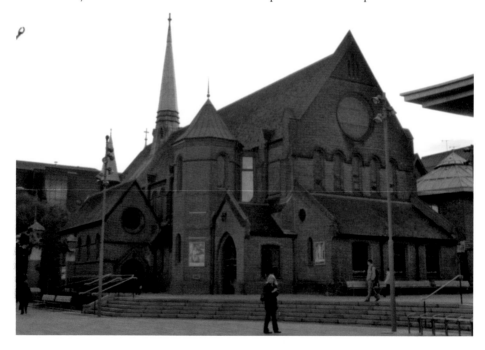

The War Memorial

In 1922, as in many other towns, a war memorial was constructed and erected in Woking Park. After the Second World War, the names of the fallen were added. Later, the memorial was moved to Sparrow Park, where it remained until the 1970s. In 1975, it was relocated to the reconstructed town square and still has pride of place in the open space near Christ Church. It is an appropriate situation as Remembrance Day services are held around it. While, in the twenty-first century, there has been yet more development in the town square, the war memorial has remained. (*Photograph above: courtesy of David Rose*)

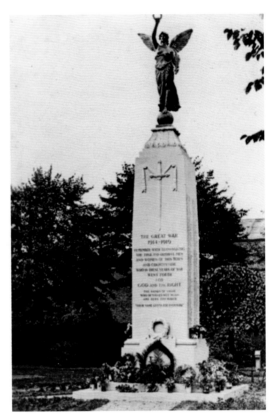

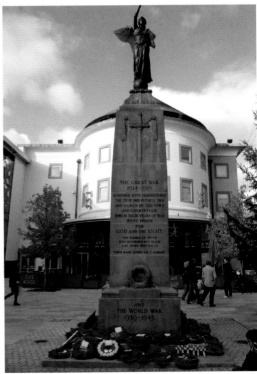

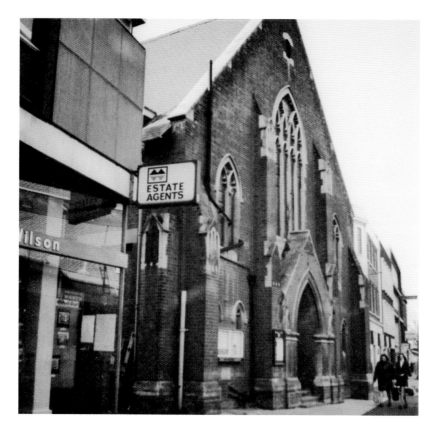

The Library

It was in the 1920s that Woking opened its first library in Percy Street. This was an iron building that had originally been a Roman Catholic church. In 1934, it moved to Chapel Street and took up residence in a converted Methodist church. It was very well used until the latter part of the twentieth century. In 1975, a new modernised building was opened in Commercial Road. In 1992, the library was relocated to the centre of the town opposite the war memorial. In 2012, it was moved yet again, as can be seen on the following page.

Café Rouge

During the latest redevelopments in 2012, the library was shifted further back towards the canal. It continues to function excellently and now offers many other services as well as books. There are computers where visitors can 'surf the net' or check their emails. There are even facilities for beginners to learn about the latest technology. Woking has an abundance of excellent coffee shops and restaurants, but there is always room for one more! In 2013, Café Rouge opened its doors on the site of the original library in town square. It is a popular, all-day venue and even has tables outside for visitors to brave the weather or enjoy the sunshine.

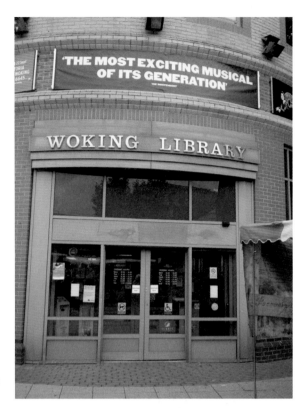

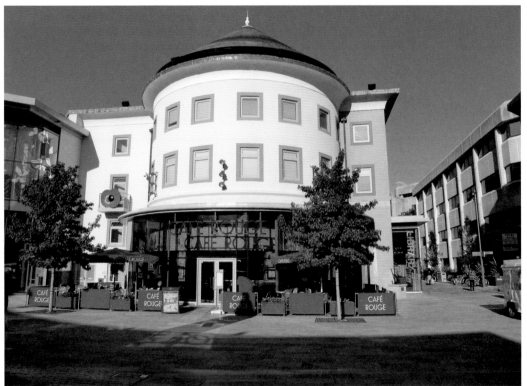

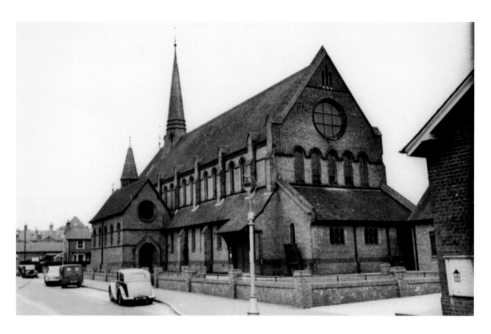

The Ambassadors

Until the 1970s, concerts and plays were held in Christ Church Hall, situated near the church. It was not an ideal venue as the sound was not good and, although the stage was raised at one end, the chairs were not tiered. In 1975, the Rhoda McGaw Theatre, named after a Woking councillor, was built on the site of Christ Church Hall. The theatre seated 230. When, in the 1990s, the huge Ambassadors entertainment complex was built, the Rhoda McGaw became part of it. The Ambassadors now features a 2,000-seat auditorium, the Victoria Theatre, and six cinema screens. (*Photograph above: copyright of Surrey History Centre*)

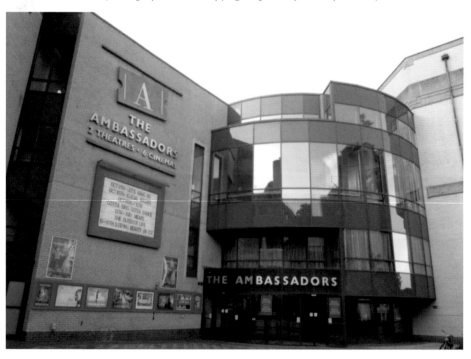

Basingstoke Canal

Running through Woking from Wheatsheaf Bridge in the town centre to Kiln Bridge in St John's Village, the Basingstoke Canal was opened in 1793. It transported timber, coal and other goods. When the railway was being built, it carried the equipment needed for that. Unfortunately, once the railway lines were completed, trains were used for transportation and the canal lost its trade. As the canal went out of use, it became filled with green algae and was rather unpleasant. During the 1990s, it was cleaned up, and houseboats and barges now make use of it. Walkers and cyclists can often be seen on the towpath. At Easter, the Canal Boat Festival is held.

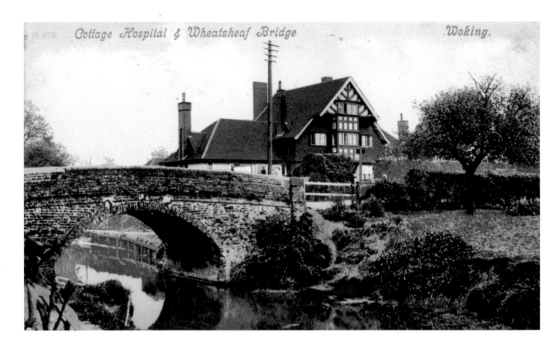

Wheatsheaf Bridge

When the canal was built, it was necessary to build bridges. This enabled the local brick kilns and brickyards in St John's and Knaphill to expand. The original Wheatsheaf Bridge was built of local brick and was only 11 feet wide. It was demolished in 1913 and replaced by a metal one. The metal bridge is still in place and connects the town to Chobam Road and Brewery Road. The bridge in Brewery Road has recently been replaced and the car park now sits under the new Living Planet Centre.

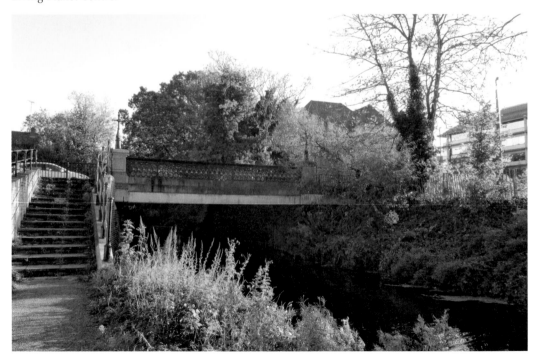

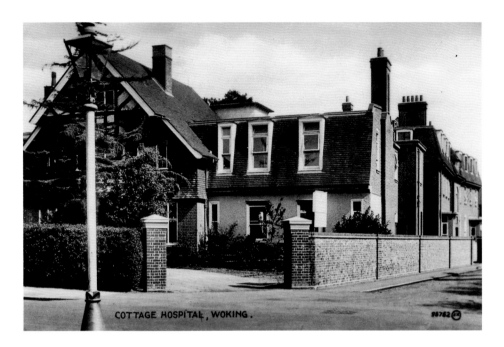

COTTAGE HOSPITAL, WOKING.

Victoria Cottage Hospital

In 1897, the foundation stone of a new hospital was laid next to the Wheatsheaf Bridge. As that year was the Diamond Jubilee of Queen Victoria, it was named in her honour. In 1903, public subscription enabled it to be extended and it continued to serve as the Victoria Cottage Hospital until 1990. In 1990, the Cottage Hospital was replaced by the new Woking Community Hospital in Heathside Road. Apartment blocks now stand on the site of the original hospital.

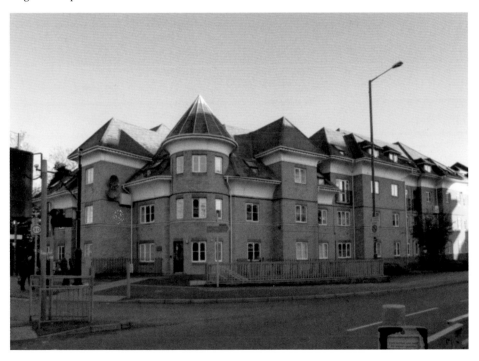

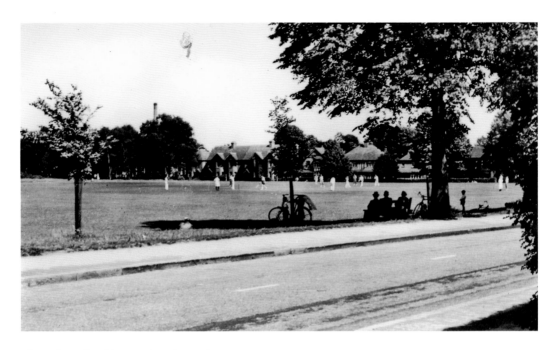

The Wheatsheaf Recreation Ground

A cricket club in Woking was formed in 1866 and teams played on the Wheatsheaf Green in Chobham Road. In 1893, a wire fence was placed around the pitch, swings were erected at one side of the green and football posts stood at the end near the Common. There was still plenty of room for impromptu games of cricket and football. The area is still used regularly and has changed little. Swings and a playground are still available and a path beside it leads to the 'Woods', a popular area for walkers. Trees can be seen on the skyline behind the grassed area.

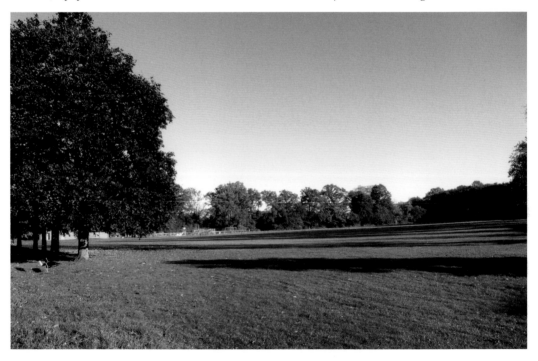

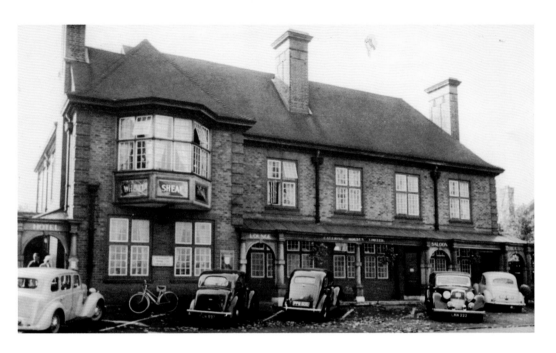

The Wheatsheaf Hotel

The hotel was probably built in the early nineteenth century. In 1849, Rueben Percy became the landlord of the Wheat Sheaf Inn. Crofter's Cottage, which stood next to the present hotel, was probably the site of the original inn. It was Percy who built the Albion Hotel in 1846. During the twentieth century, the hotel changed hands several times. It is now part of Ember Inns and continues to provide customers with accommodation and a varied menu of delicious food. (*Photograph above: courtesy of David Rose*)

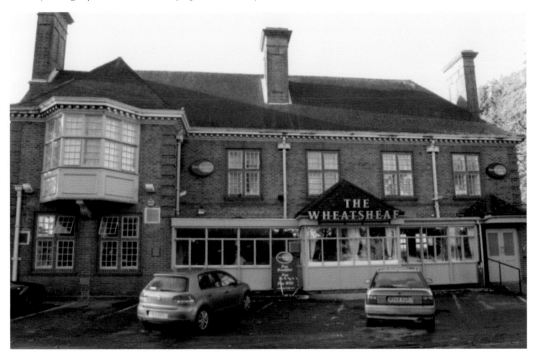

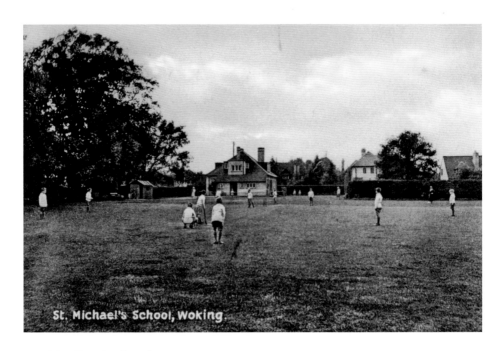

St. Michael's School, Woking.

St Michael's School & Shaw Centre

In the 1930s, St Michael's School was probably founded as a small, private school for boys. It was situated in Chobham Road beside the Wheatsheaf Common. By the 1940s it needed bigger premises and took up residence in Brynford, a large house on the corner of Grange Road and Woodham Road. It later accepted a few girl pupils. The original building became a children's nursery and is now the Shaw Centre, which is a department of Social Services. 'Brynford' has disappeared and has been replaced with smaller houses but the name remains as Brynford Close.

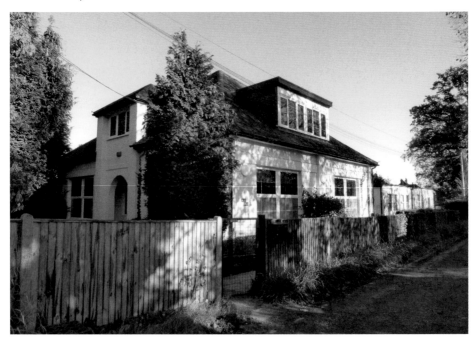

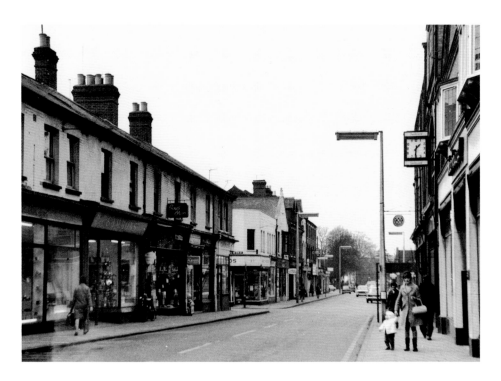

Chobham Road

Cottages were built in Chobham Road in the late nineteenth century but these were later replaced with shops. Among these were Gammons, a draper's shop, and Wearing's the Chemist. In 1890, electricity came to Woking and the Woking Electric Supply Company opened in 1889. In the 1970s, most of the early shops disappeared. At the town end of the road, they were replaced by other shops, but once over the Wheatsheaf Bridge the area became more rural and in autumn there is a blaze of colour. (*Photograph above: courtesy of David Rose*)

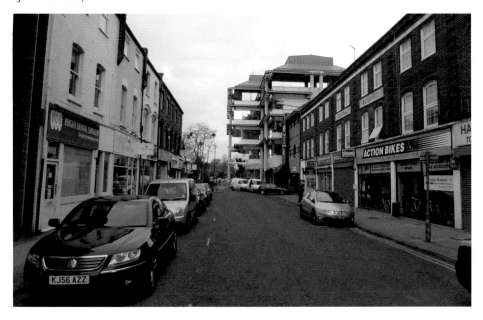

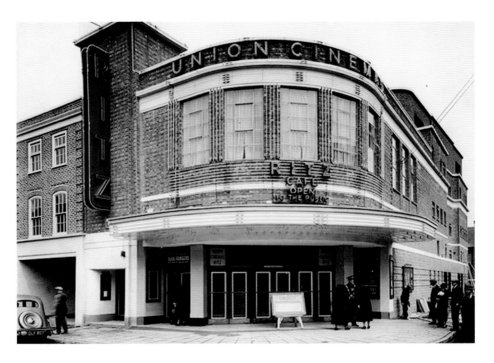

The Ritz Cinema

The last of the three cinemas to be opened was The Ritz, which was built in 1937 on the corner of Chobham Road and Commercial Road. It was a popular venue and boasted a restaurant where visitors could relax after seeing a film. It was the last of the cinemas to close. The Ritz is now known as Hollywood House, an appropriate name as the cinema would have shown the latest Hollywood films. However, after its disappearance as a cinema, it became a Bingo Hall. Today, however, the building is an office block. (*Photograph above: courtesy of David Rose*)

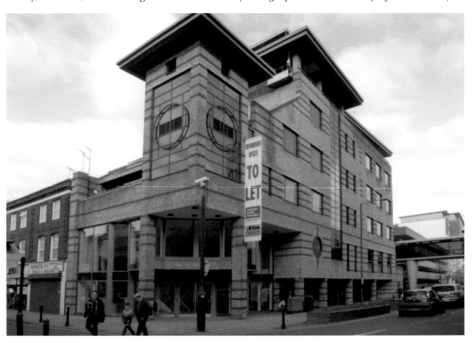

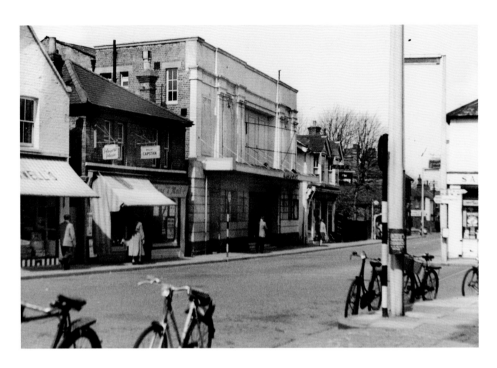

The Gaumont Cinema and Shots Pool & Sports Bar

In March 1912, the Centre Hall Cinema was opened in Chertsey Road. It proved a popular venue for seeing the latest films. In 1927, it changed hands and became the Plaza Cinema. Its last reincarnation was as the Gaumont Cinema, which survived until the late 1950s. The cinema and the surrounding area was demolished in the 1950s. Today, the Metro Hotel and Shots Pool & Sports Bar stand on the site. The other entrance of the latter is in The Big Apple situated in Commercial Road. (*Photograph above: courtesy of David Rose*)

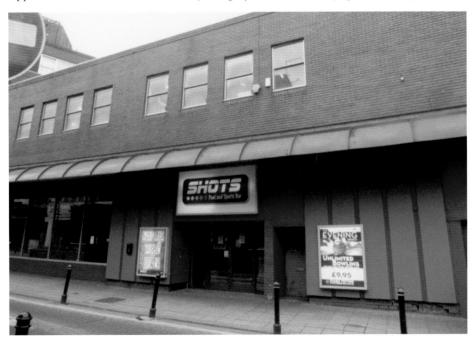

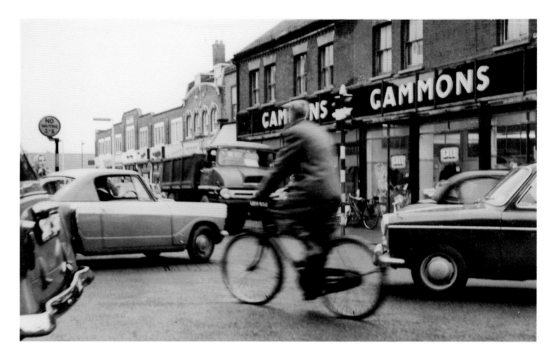

Gammons

'James Gammon, Draper' was listed in the shops' directory of 1899. Gammons was still a popular draper's shop well into the twentieth century. For a while, this area on the corner of Chobham Road and Chertsey Road was known as 'Gammons Corner'. In the 1970s, the area was redeveloped and a number of shops were built on the site. Sadly, this part of Woking has lost its character, and shops in this and other areas are frequently changing hands. (*Photograph above: courtesy of David Rose*)

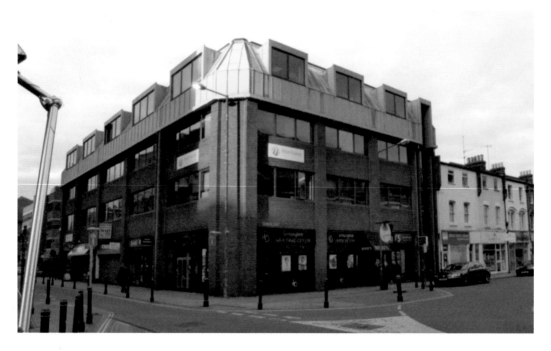

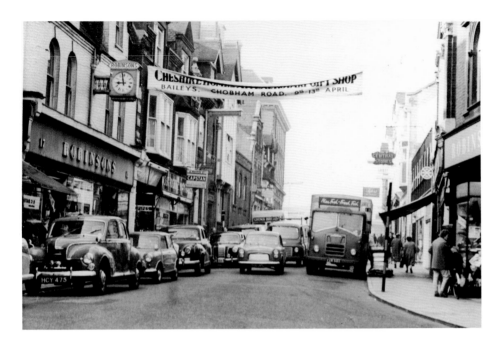

Chertsey Road & Woking Kebabs

Towards the end of the nineteenth century, shops were built in Chertsey Road, which became the main shopping area. Ashby's Bank, situated on the corner opposite the station, was built in 1888. In the twentieth century, it became Barclay's Bank. Today the building houses Budgens supermarket. The post office was opened in 1895, next to the bank. Pullinger's, a baker's, was on the opposite side of the road. The post office in Chertsey Road remained in use until 1960 when it was relocated to Commercial Road. The original site now serves Woking Kebabs! Pullinger's has been replaced by Sopranos, a hairdresser's.

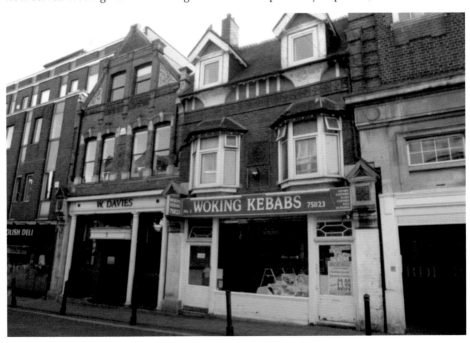

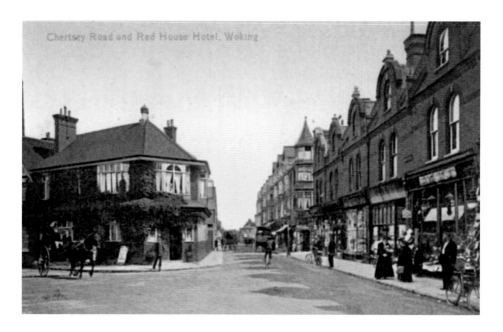

The Red House Hotel & Ladbrokes

Development continued in the late nineteenth century. In 1869, the Red House Hotel was built on the corner of Chobham Road and Chertsey Road. In 1936, it was demolished to be replaced by a number of shops. At this time there were no drains or sewerage systems and sewage would leak on to the roads. The proprietor of the hotel was prosecuted for allowing this! The hotel disappeared with the redevelopment of the 1970s. Burton's, the gentlemen's outfitters, was established in 1936 and the site originally belonged to the Red House Hotel. The site of the hotel is now occupied by Ladbrokes, the bookies.

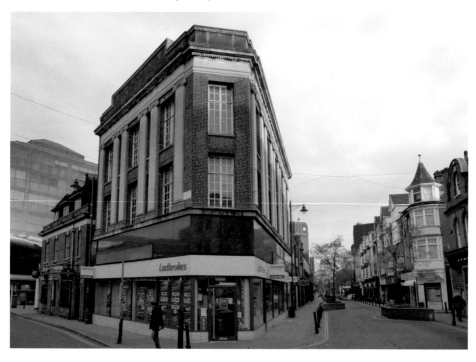

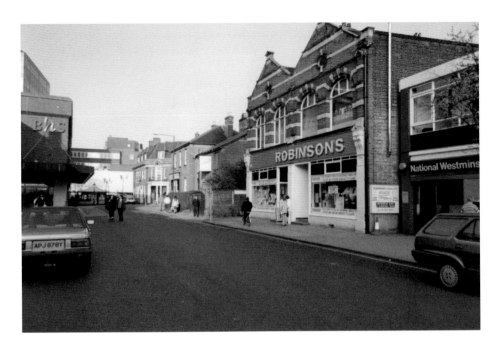

Robinson's Department Store & McDonald's

In 1934, William Robinson opened a new drapery store and ladies' outfitters in Chertsey Road. This was the only department store in the town and the restaurant on the upper floor, using Harrod's caterers, was very popular. It was a great loss to the town when it closed in 1997. With Robinson's gone, it was not long before the building was utilised for another purpose: a McDonald's now occupies the site! It continues to provide the public with its ever popular burgers and chips. (*Photograph above: courtesy of David Rose*)

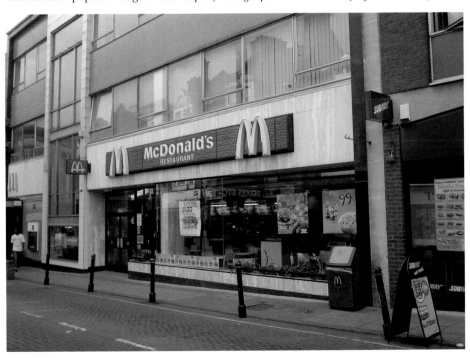

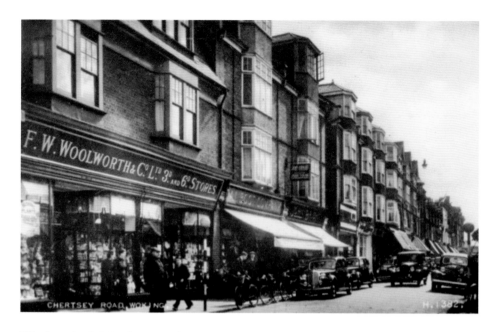

Woolworths & Weatherspoon's

Known as the '3d and 6d stores', the famous F. W. Woolworth store opened in Chertsey Road in 1926. Part of it was hit by one of the few bombs to fall on Woking during the Second World War. In 1958, the original building was demolished and a more modern store built. Sadly, in later redevelopments, this too disappeared and today Woolworths is no more. The site of the original building is now occupied by Weatherspoon's, the popular bar and restaurant serving food all day long.

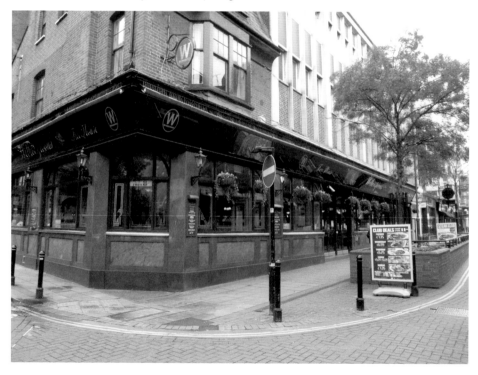

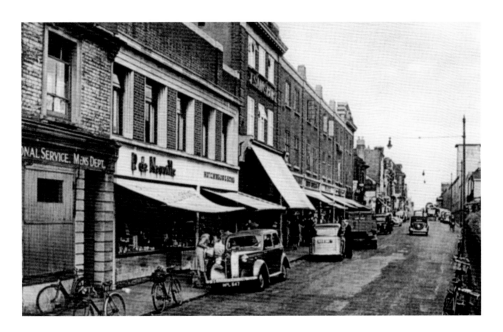

The High Street

In the late nineteenth century, shops appeared in the High Street opposite the railway line. Many of these shops disappeared in the redevelopment of the 1970s and 1980s, but others took their places. The mural, unveiled in 1993, shows the original shops in the High Street as they were at the beginning of the twentieth century during the Edwardian period. Most of the shops have now changed hands but the High Street is still as busy as it ever was. (*Photograph above: courtesy of David Rose*)

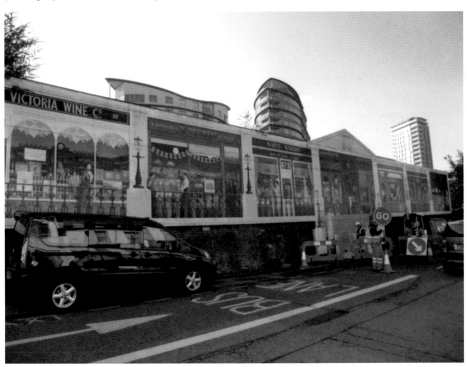

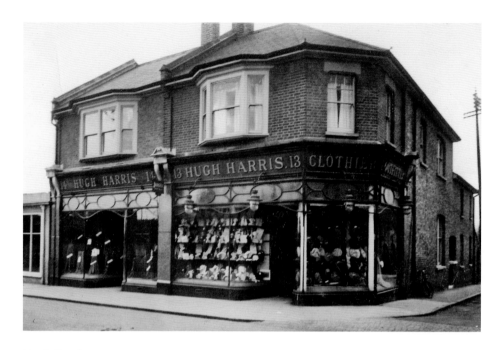

Hugh Harris

Originally employed in his family's building firm, Hugh Harris left it in 1914 to set up a new business as a gentlemen's outfitter at Nos 13–14 High Street. In 1946, he retired and sold the shop to Henry Martin. When Henry Martin retired, his son Paul took over. Paul Martin is still the managing director and the shop is still on the same site. In the early nineties, it was Paul Martin who persuaded the Council to erect the mural on the railway embankment. Another shop has recently been opened in Wolsey Place.

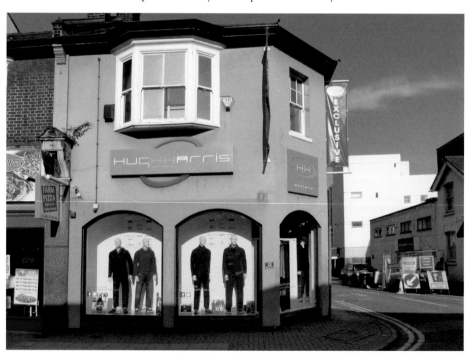

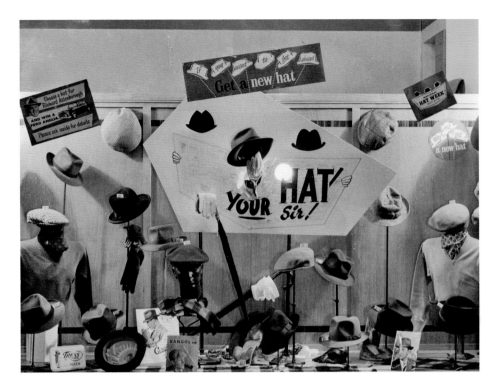

A Window Display

The fascinating display in the picture above shows the variety of headgear that gentlemen of an earlier age would have worn. Gentlemen wore hats all the time when they were outside but always removed them on entering a building. There would have been caps and hats to suit every occasion. Today, the current window display shows models wearing both leisure and more formal attire. There is no sign of hats, although I am sure they could be provided if necessary. Today's clientele are more casual!

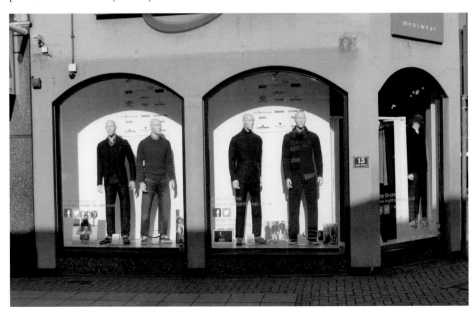

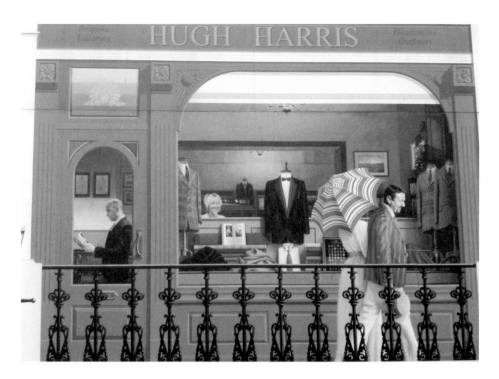

An Appropriate Link

As it was Paul Martin who suggested the mural, it seems appropriate that he should include one of his employees in the Hugh Harris picture. The gentleman on the left in the mural above is Lee Simpson, the current director of Hugh Harris. Below, Lee is shown serving in the present shop. This provides an excellent link between the old shop and the new shop. Outside on the wall of the shop is an engraving of the mural and its origin.

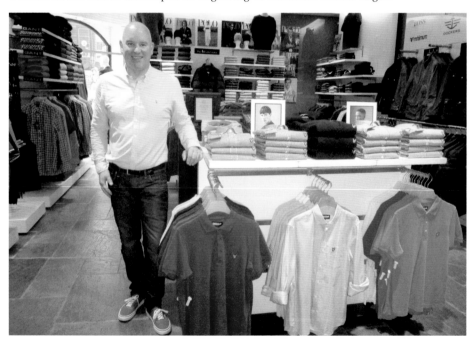

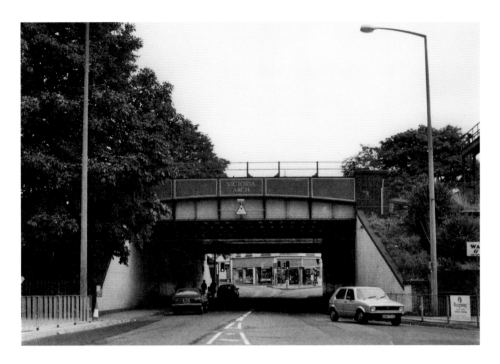

Victoria Arch

The fact that the centre of Woking was bordered by the railway line on one side and the canal on the other caused and still causes traffic problems. Much of the traffic has to pass under the narrow railway arch at the entrance to Guildford Road. This inadequate arch was rebuilt in 1907 and renamed Victoria Arch in honour of the Queen. Today, Victoria Arch is busier than it ever has been and still links the railway and the canal. Roads from several directions approach it and the traffic lights from the town help the flow of traffic to some degree.

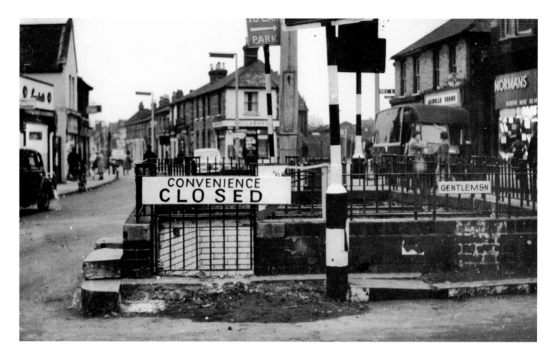

A Closed Convenience

At one time this was the only public convenience that Woking boasted. Nowadays, of course, there are 'Ladies' and 'Gents' in most restaurants and even some shops. This public convenience has now disappeared. Now situated on the site of the 'convenience' is a small food stall where visitors can assuage their hunger before moving on to sample the delights of the main market. (*Photograph above: courtesy of David Rose*)

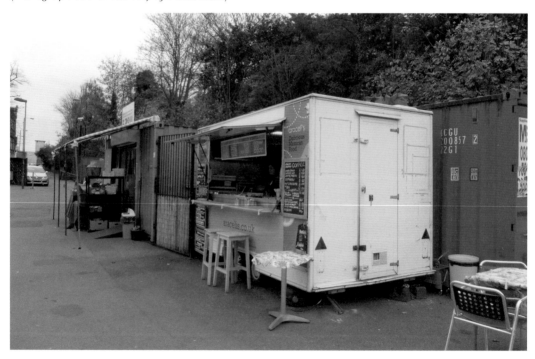

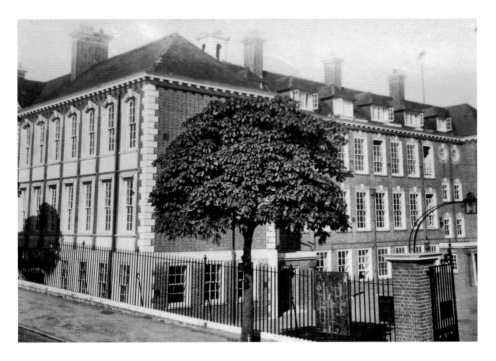

The Boys' Grammar School & the Police Station

In 1914, the Boys' Secondary School opened in Guildford Road with less than fifty pupils. Thirty years later, the number of boys had increased and it became the Boys' Grammar School. In 1982, the school closed and a sixth form college opened in Kingfield. In 1990, the building of the Boys' Grammar School, with its distinctive cupola, became the new police station and remains so today. (*Photograph above: copyright of Surrey History Centre*)

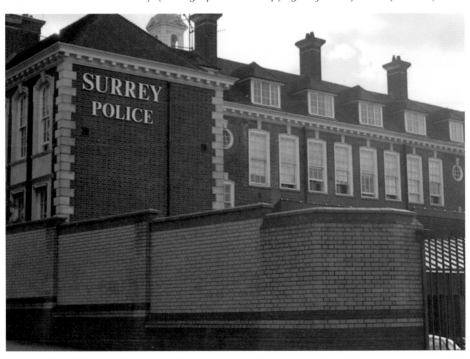

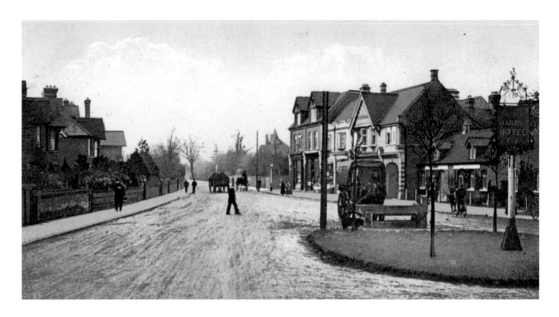

Guildford Road

George Raistrick owned much of the land south of the railway and refused to sell it for development. However, when he died in 1905, the land was promptly sold and shops were built on both sides of Guildford Road. Those on the west side were demolished in 1983 and replaced by offices. Many of those on the east side remained but have changed hands several times.

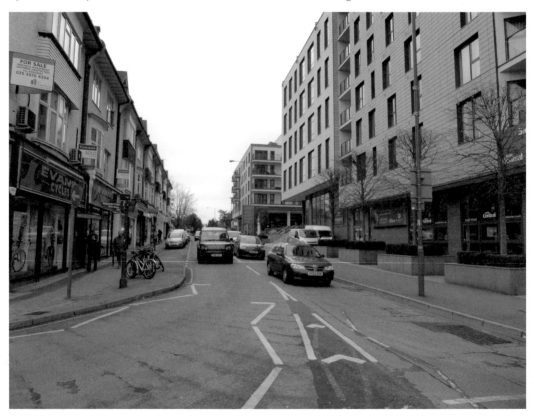

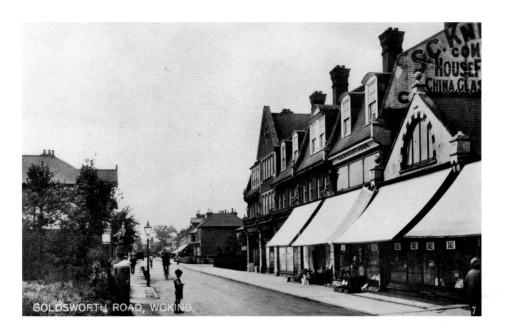

Goldsworth Road

Originally, this area had been an ancient hamlet with small farms and cottages dotted along the winding track. After 1860, the land was sold and a new suburb grew. However, there was no proper sanitation and there was an 'overflow of sewage and liquid filth' into Goldsworth Road as houses with 'nothing but buckets for sink water' were being built. At the end of Goldsworth Road where it joins Trigg's Lane, the roundabout is probably a remnant of 'Goldsworth Green', which, in 1880, extended to Arthur's Bridge Road and consisted of over 11 acres. After the Second World War', the Goldsworth Road area was redeveloped, and houses and shops today have proper sanitation. (*Photograph above: courtesy of David Rose*)

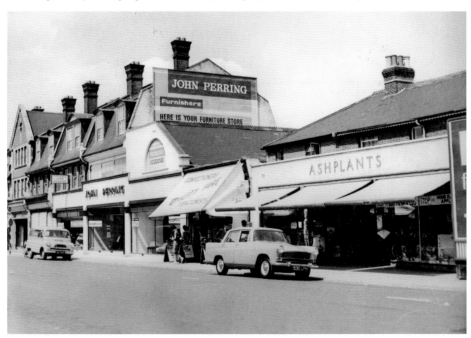

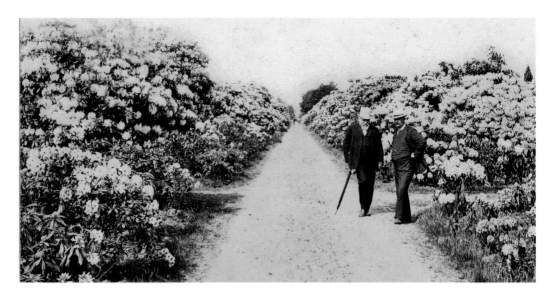

Jackman's Nursery & Woking Garden Centre

William Jackman established his nursery in Goldsworth Road in the early nineteenth century. By 1870, he had absorbed the nearby nursery founded by James Turner in 1760. In the twentieth century, Jackman's Nursery was the most popular one in the area. It still flourishes in Goldsworth Road as part of the 'Garden Centre Group', under the name of Woking Garden Centre. It produces a variety of seeds, flowers and shrubs, as well as providing a café.

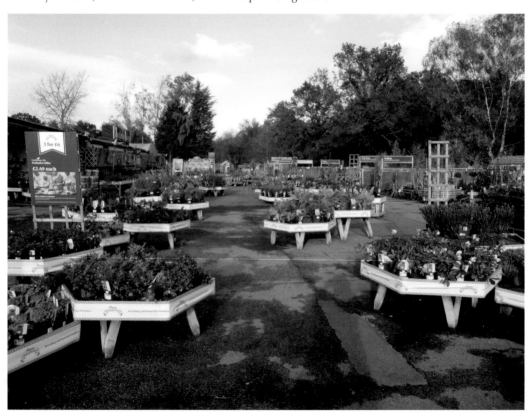

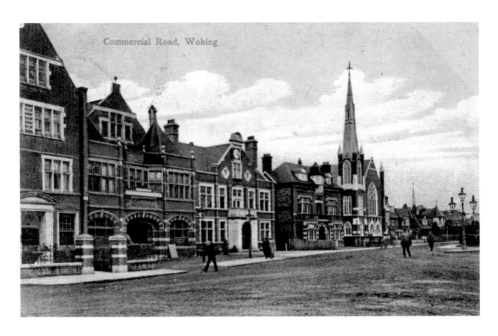

Commercial Road, Woking

Commercial Road & Circle 7

Towards the end of the nineteenth century, the town of Woking started to evolve – rather haphazardly. At the end of Commercial Road, several public buildings were built including the Public Hall, which later became the Grand Theatre. In 1904, the offices of the Woking Urban District Council were built next to it. These buildings were used for many years as the council offices. All were demolished in the 1960s. Today, Circle 7 stands next to an empty site where the post office once stood. It sells everything from butterfly nets to thermal ice scrapers. Apparently its new name will be 'What you Need Ltd', which is very appropriate.

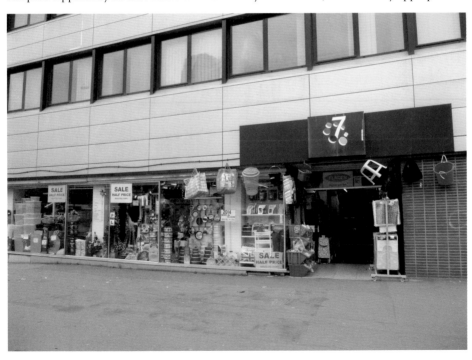

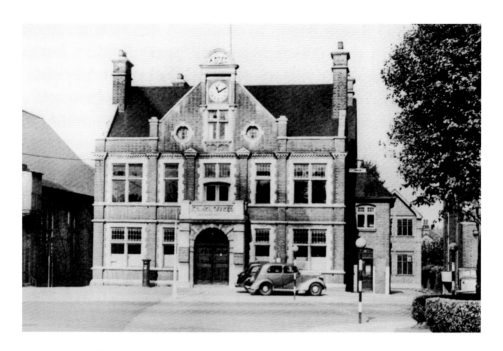

The Council Offices

Woking Urban District Council originally occupied offices above Ashby's Bank in The Broadway. In 1899, the offices were destroyed by fire and they were moved to new premises in Commercial Road. With the redevelopment in the 1980s, a new building was erected to house the Woking Borough Council in Gloucester Walk opposite the canal. The original site is now occupied by Circle 7, as seen in the previous photograph. (*Photograph above: courtesy of David Rose*)

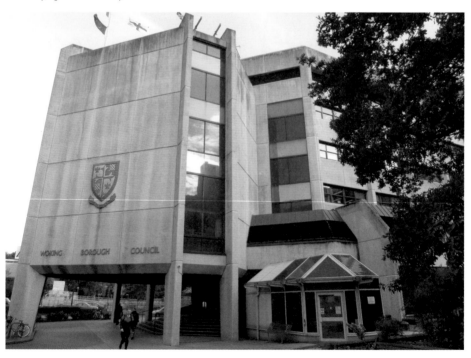

The Wesleyan Chapel & Toys 'R' Us
In 1862, the first Wesleyan chapel was
built in Chapel Street. In 1884, a larger
church was built in Commercial Road
adjoining the small chapel; the latter
became the public library in 1929. In
1905, a larger building was erected
further down Commercial Road. Because
there has been so much redevelopment,
it is quite difficult to identify all the
original sites. It is likely that the very
popular toy shop Toys 'R' Us has replaced
the Wesleyan chapel. (*Photograph above:
courtesy of David Rose*)

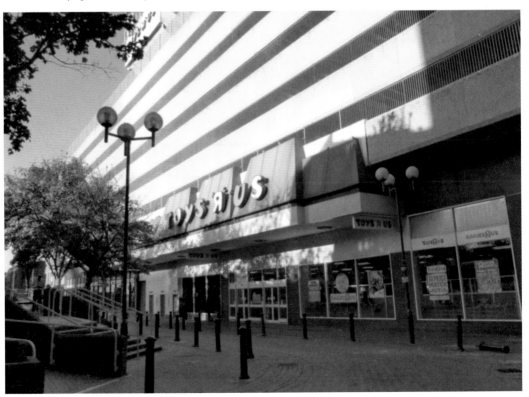

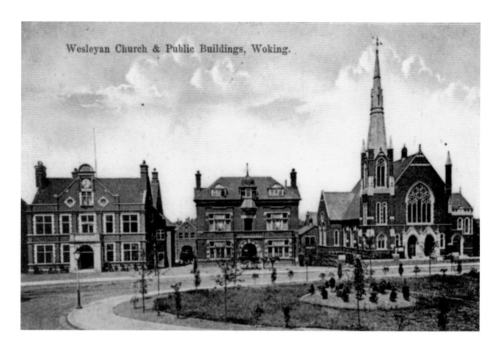
Wesleyan Church & Public Buildings, Woking.

Sparrow Park

In 1904, a small garden was laid out at the end of the High Street. It became known as Sparrow Park not only because of the birds but also on account of its small size. After being moved from the park, the war memorial stood there until 1975 when, as part of the new development, it was moved to the centre of the new town square. Perhaps today, Sparrow Park should be renamed 'Pigeon Park' as pigeons have taken up residence there. The war memorial has been moved so there is more room for them to browse. Pigeons are very fond of Woking!

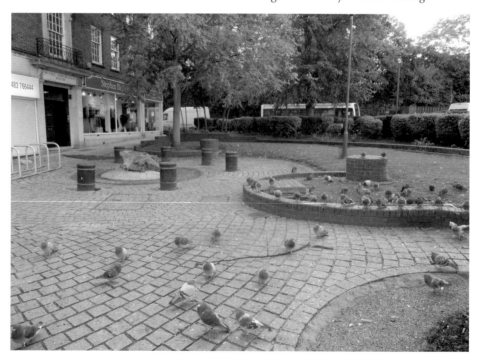

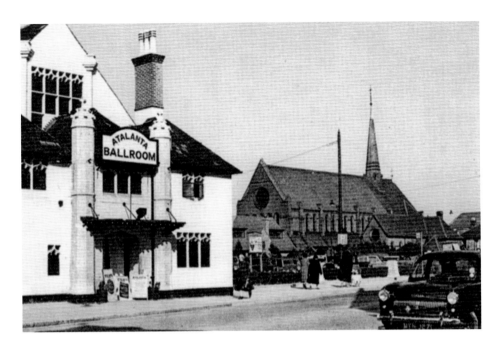

Atalanta Ballroom & Peacocks

Originally built as a manse for the Wesleyan chapel, this building was eventually transformed into the Atalanta Ballroom. It had an excellent sprung floor, a resident band and over the years played host to a number of celebrities. Sadly, the Atalanta was demolished in 1972. Today, the Peacocks occupies the site both of the Atalanta Ballroom and the nearby car park. This consists of two shopping floors, a food hall with a selection of eating places and four floors for car parking. The first car parking floor also contains the box office for the theatres and cinemas, and leads to The Ambassadors complex.

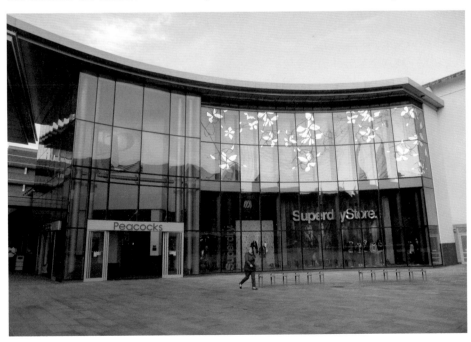

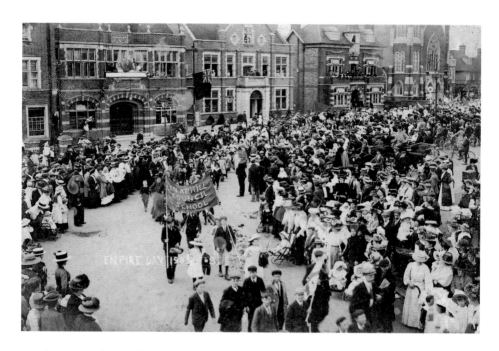

Empire Day & the Market

Empire Day, held annually on 24 May, was celebrated well into the twentieth century. As the Empire metamorphosed into the Commonwealth, it was no longer relevant. In the photograph above, residents are enjoying the day in the area now occupied by the market. The daily market in Woking has been popular for a number of years. It has moved its position several times and its current position near the Victoria Arch may not be its permanent one.

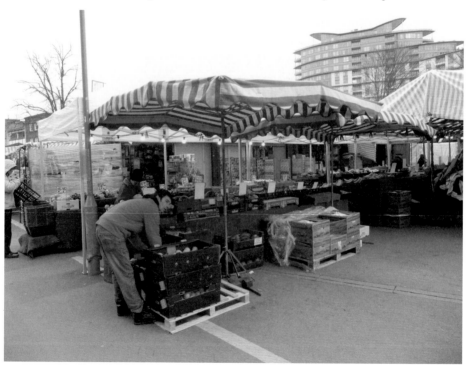

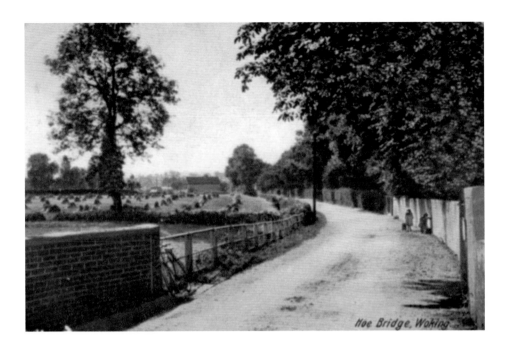

Hoe Bridge

A bridge was built in the middle of the nineteenth century, although there may have been earlier ones. The name 'Hoe' may be derived from the old English 'hoh' which meant 'spur of hill'. The remains of the bridge can be seen but now the main attraction in this area is the popular Hoe Bridge Golf Centre, which, as well providing exercise, also boasts a bar and restaurant. On Sundays there is a carvery in the restaurant.

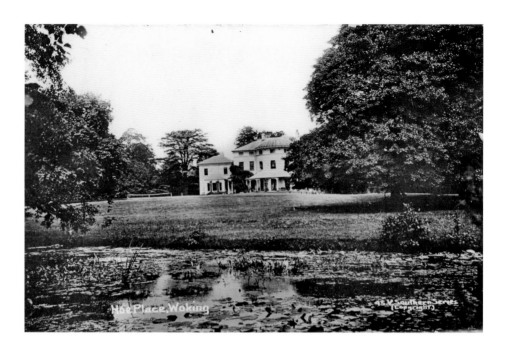

Hoe Place

Woking Palace, the home of Margaret Beaufort and frequented by royalty, was sold in 1618 by James I to Sir Edward Zouch, who demolished some of the buildings and used the materials to construct an impressive mansion for himself named 'Hoe Place'. Later, it became a private residence and until the 1920s it was owned by the Booth family. The building was sold and in 1928 Hoe Place Preparatory School was established. In 1962, it merged with St Michael's School and then in 1986 with Allen House in Guildford. In 1986, it became known as Hoe Bridge School and that is still its name. (*Photograph above: courtesy of David Rose*)

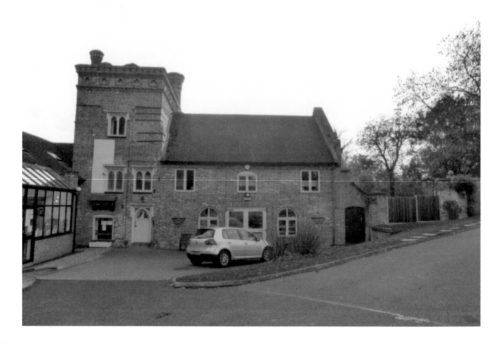

Monument Bridge

Having been granted the Manor of Woking by James I, Sir Edward Zouch built a 6-foot tower on Monument Hill – probably so that he would be remembered! It collapsed in the 1860s but has given its name to Monument Road. Monument Bridge over the canal was rebuilt in the late 1930s at a cost of nearly £13,000. Half of this was funded by the Ministry of Transport. The bridge and the road still remain and a huge office block has been erected beside the canal. In 2013, redevelopment of the nearby Sheerwater area necessitated traffic lights while the new road was being constructed. This was completed in November 2013, but other roads are still under construction.

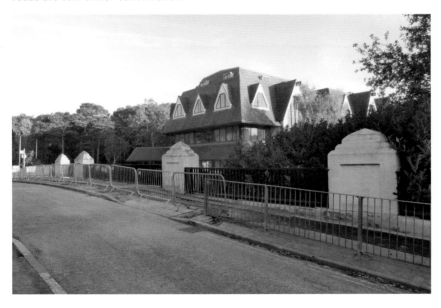

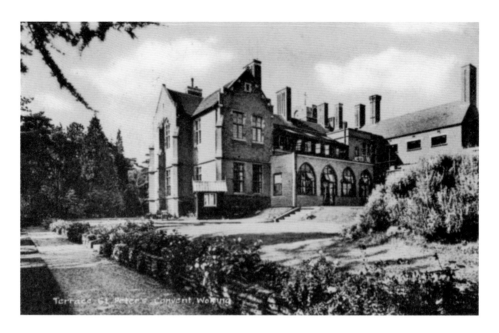

Terrace, St Peter's Convent, Woking

St Peter's Convent

The community of St Peter was founded in London, but in 1883 it moved to Maybury when St Peter's convent was built to provide accommodation 'for such of the sick poor as are members of the Church of England and require nursing'. A chapel was later completed in 1908. The Anglican nuns continued to run the nursing home until the end of the twentieth century, when the site was sold and the buildings were converted into residential units. The area is appropriately called Convent Close.

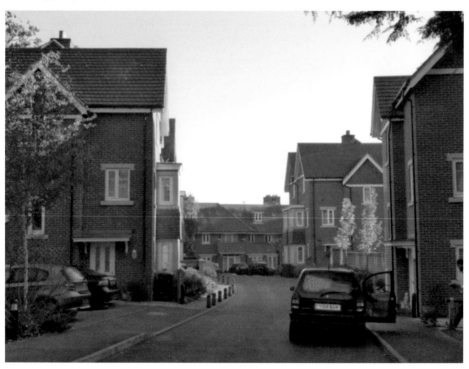

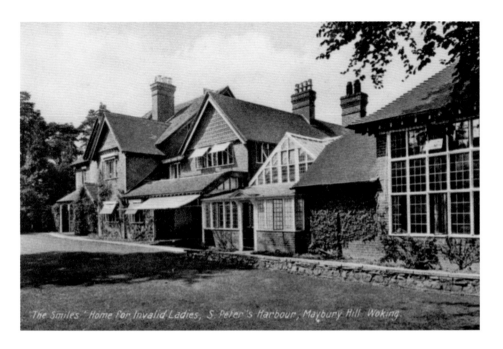

"The Smiles" Home for Invalid Ladies, S. Peter's Harbour, Maybury Hill, Woking.

The Smiles Home for Invalid Ladies

Since its inception, Woking has always cared for its elderly and, over the years, there have been many care homes. One of these was the 'Smiles Home for Invalid Ladies' in Lavender Road. This luxurious abode, set in beautiful grounds, sadly disappeared in the 1970s. More residential units were built and the area was given the name Smiles Place in memory of the care home.

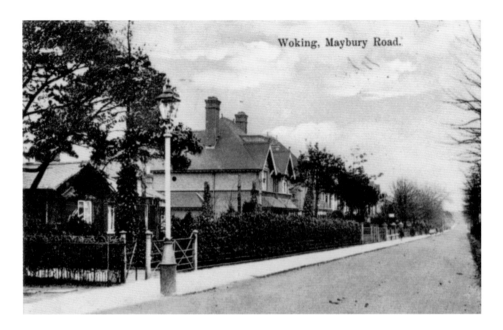

Woking, Maybury Road.

Maybury Road

In 1888, some of the land immediately north of the railway line was sold. Maybury Road then started to develop. Detached and semi-detached houses were built on it. Many of them still remain today. One of the houses contains a plaque informing viewers that H. G. Wells lived there. He wrote *War of the Worlds* while resident in Woking. The road provided the bus route leading to The Broadway, where most of the local buses still start their journey. It runs alongside the railway. In the 1970s, the vicar of St Paul's church was disturbed by the number of accidents in the road. He suggested to the Council that it should be a one-way street running only towards the town. It continues to be so. The one-way street coming from the town is Walton Road.

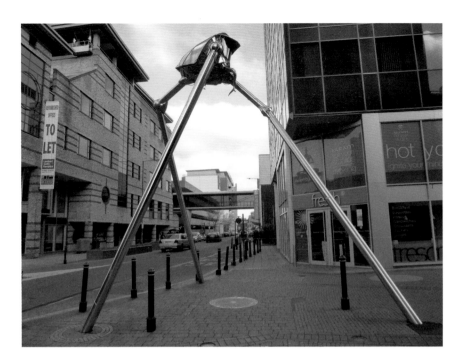

H. G. Wells

Often described as 'the father of Science Fiction', H. G. Wells lived from 1895 to 1898 in 'Lynton', a small detached house in Maybury Road. Here he wrote three of his novels, including *The War of the Worlds*, first published in 1898. In this novel, Martians invade the town of Woking and destroy it. To celebrate the centenary of the book's publication, a huge stainless steel statue – *The Martian Landing* – was installed in Crown Passage in 1998. At the same time as the Martian was erected, the H. G. Wells Centre was opened in Commercial Road. The conference and events centre hosts a variety of events and contains conference rooms as well as venues for concerts.

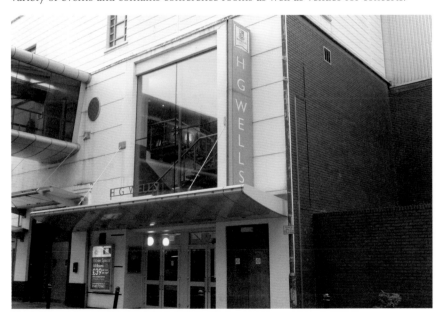

Maybury Hill

'Bunkers Hill' was the original name of Maybury Hill. In 1865, the Prince of Wales visited Woking to open the Royal Dramatic College. He objected to the name as it reminded him of a British defeat so the area was renamed Maybury Hill. This hill was also the site where, according to H. G. Wells, the Martians landed at the end of the nineteenth century. Today, Maybury Inn is on the corner of Old Woking Road and Maybury Hill. Like other roads in the area, it is tree-lined. Its 'rural' atmosphere is usually shattered by the amount of traffic making its way to the main road and then through Send to the A3 and Guildford.

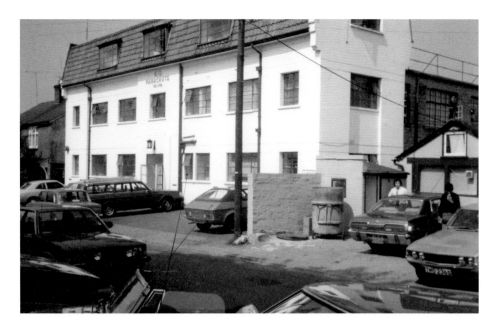

The Parachute Company

In 1934, the GQ Parachute Company moved to Portugal Road, having started work in Guildford. In 1938, a two-storey factory was built and the company continued to design and produce parachutes during the Second World War. After the war, the company was absorbed into a larger one but continued to provide parachutes under its original name. They continued to do so until 1987, when the firm was relocated to South Wales. At the end of the twentieth-century flats were erected on the site. Portugal Road and Marlborough Road next to it both have two-way traffic. North Road, another road that links Maybury Road with Walton Road, is only one-way.

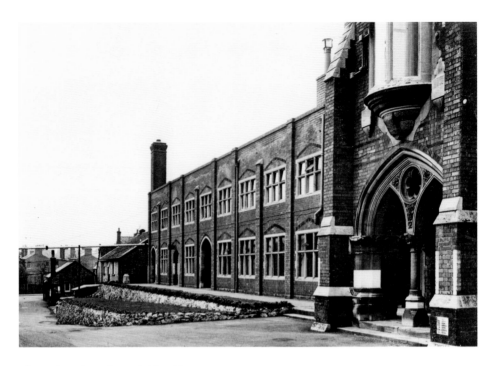

The Oriental Institute & Lion House

In 1883, the defunct Royal Dramatic College, which had opened in 1865, was bought by Dr Gottlieb Wilhelm Leitner, who transformed it into the Oriental Institute. Although this closed on the death of its founder in 1899, it gave its name to Oriental Road. The building was later used as the company head office of the Lion Works. When the Lion Works buildings were demolished, the site was empty until the retail park was established. This is known as the Lion Retail Park – a reminder of the Lion Works. The headquarters of the James Walker Group is now in Oriental Road opposite St Paul's church and is called Lion House.

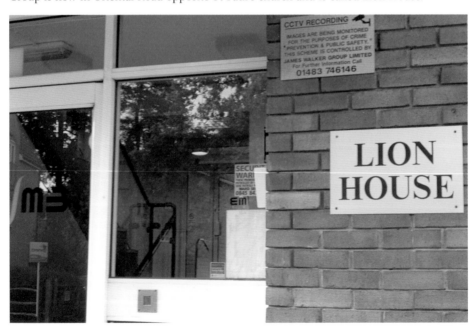

The Shah Jahan Mosque

After The Royal Dramatic College closed, Dr Gottlieb Leitner used the building for his Oriental Institute, which opened in 1889. In the grounds he built the first mosque in England. He named it Shah Jahan. Sadly, he died soon afterwards and the mosque stood empty until 1912 when a Muslim missionary came to Woking and reopened it. Since then, buildings have grown up around it. After the Second World War, many Pakistanis came to England and settled in Maybury near the mosque. Every day after school, Pakistani children wend their way to the mosque to learn Arabic and read the Koran. On Fridays, Oriental Road is crowded with people and cars as worshippers attend Friday prayers.

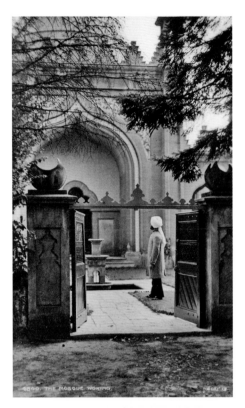

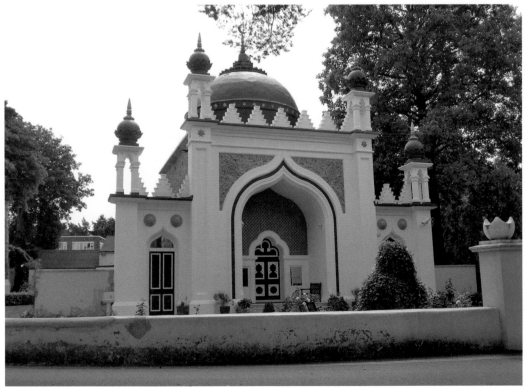

Oriental Road

Maybury Heath Lane was originally a muddy, tree-lined track crossing open heathland where trees had grown. The building of the Royal Dramatic College in 1865 encouraged the building of residential houses in the same area. The muddy track then became Oriental Road, taking its name from the Oriental Institute which had replaced the college. Today, Oriental Road is always busy as it contains St Paul's church, the mosque and the retail park. It is also a bus route to the town. The headquarters of James Walker Group, Lion House, is opposite the church, and behind the building is a large car park for those who work there.

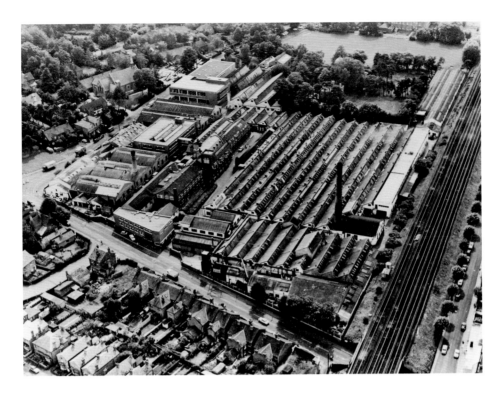

James Walker Group

In 1926, the James Walker Group Lion Works packing firm acquired the site of the empty Martinsyde aircraft factory in Maybury. The factory had taken over the remains of the building that had been the Oriental Institute. The Lion Works remained on the site until the firm closed in 1993. The site of the Royal Dramatic College, the Oriental Institute, Martinsyde aircraft factory and the Lion Works now make up the Lion Retail Park. Sadly, none of the original buildings remain, but there is plenty of choice for shoppers as it contains, among other retail shops, Curry's, Hobbycraft, ASDA and Argos.

Entrance to the James Walker Group

The original entrance to the James Walker Group is now probably the entrance to the retail car park. There are two hours free parking, but cameras are in operation and fines are charged if the time is exceeded. The gates are closed at night. Lion House in Oriental Road is situated next to the retail park car park and has its own car park behind. It is the headquarters of the company.

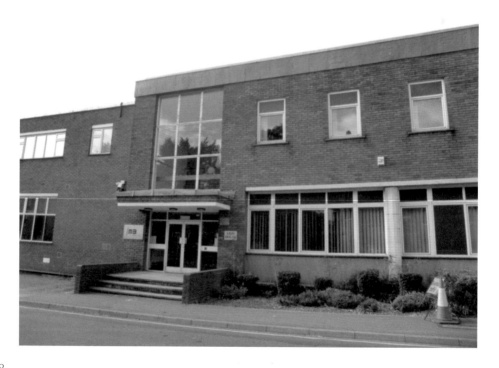

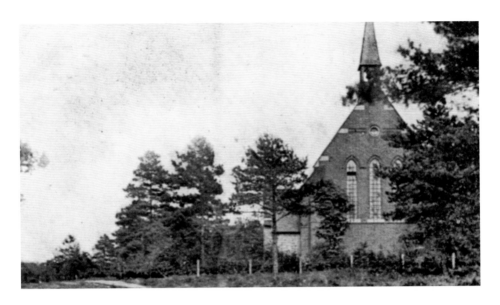

St Paul's Church

The foundation stone of St Paul's church was laid in 1884, and the church was consecrated a year later. At first it was known as the 'Church in the Trees' as it was surrounded by trees. Most of these eventually disappeared. To begin with it was a daughter church of Christ Church in the town centre, but in 1959 it became a parish in its own right. In 1995, the church celebrated its 100th birthday. There was one remaining yew tree outside the east wall of the church. After much debate, it was cut down in 2008 to make room for a small car park. The church can now be clearly seen from the road. The adjoining church hall is now the community hall and is used by many sections of the community while the church itself continues to flourish.

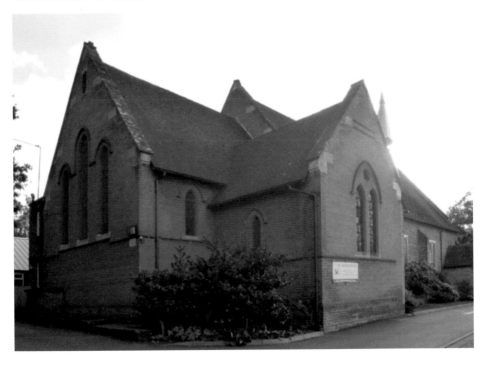

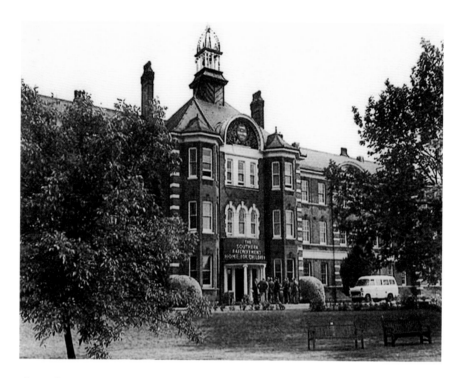

The Railway Orphanage

In 1909, the Southern Railwaymen's Home for Children decided to move its orphans to a healthier area near the railway. Land was bought in Oriental Road and a new building erected to house the orphans. It continued its function until 1960s when the number of orphans declined. During the 1970s, part of the building was used for elderly residents. In 1982, the institution became known as Woking Homes – a name it still retains. There was redevelopment in 1987 and again in 2009. Today it continues to flourish as an excellent residential home for the elderly.

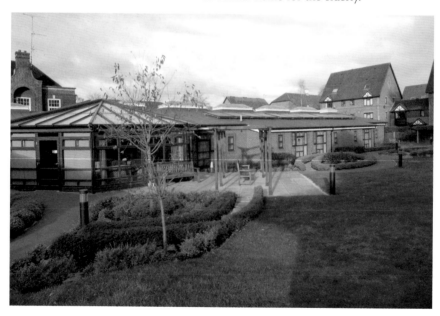

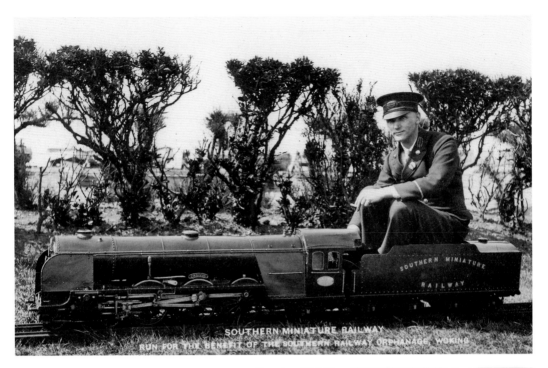

The Miniature Railway

With its railway connection it was appropriate that a miniature railway should be located here. In 1923, a rail track was built round the sports field of the Railway Orphanage. A miniature steam engine ran around it to entertain the children. Later, it also proved very popular at the annual garden party of Woking Homes. The first phase of the rebuilding was completed in 1990 and the new buildings were officially opened by His Royal Highness the Duke of Gloucester. He obviously could not resist a ride on the miniature railway. Sadly, it disappeared in 2009 to make way for more buildings.

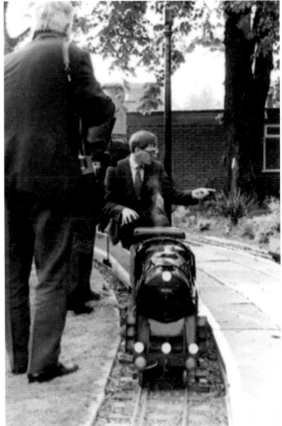

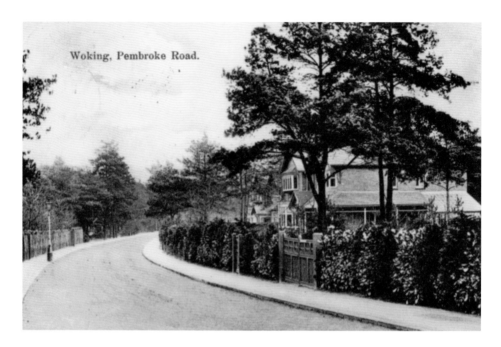

Woking, Pembroke Road.

Pembroke Road

In the 1860s, luxurious residential houses were built in Pembroke Road. Continuing along this road, Hockering Estate was established between the two World Wars by the Smallpiece family, who owned the land. They originated in the seventeenth century in a Norfolk village called 'Hockering' and they used the name for the estate. Pembroke Road today boasts a number of trees and it is still a residential area. St Paul's Vicarage is situated behind the church and a newly paved cycle path links Pembroke Road with Oriental Road. As the land belongs to the church, the path has to be closed to the public on one day each year.

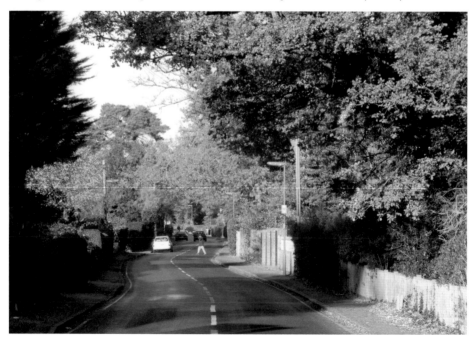

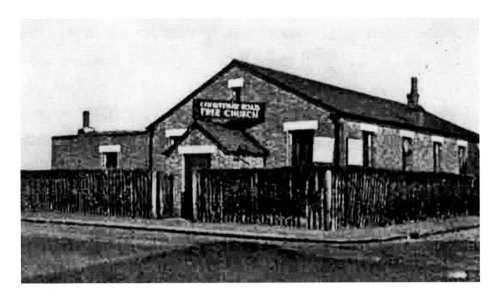

Courtenay Road

A small building in Courtenay Road that had once been a laundry was converted into a church meeting room and the first service was held in November 1905. In 1922, the lease ran out and notice was given to leave the building. Money was found and a new building erected. This was used until 1969, when the council acquired the land for redevelopment. Eventually land for a new church was bought in Walton Road. There was an almost derelict hut on it that had been used to store parachutes during the Second World War. A new building was erected on the site and Courtenay Free Church still continues to meet there regularly.

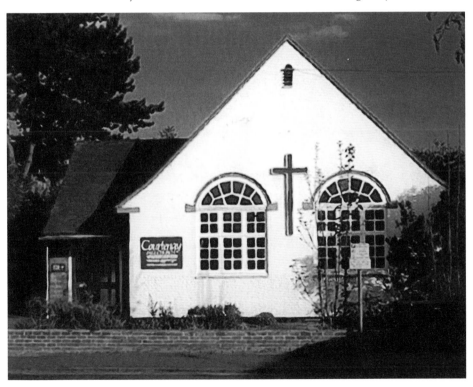

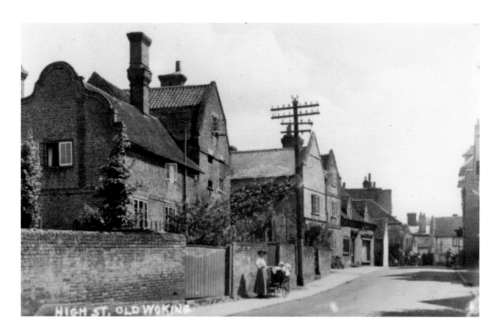

High Street, Old Woking

This area, known to the Saxons as Wochingas, was included in the Domesday Book of 1086. The Manor of Woking was owned by the King who often hunted in the area, which was part of the royal forest of Windsor. In the fifteenth century, Henry VI granted a charter allowing an annual fair to be held. This was held regularly until the 1870s, and became known as the Toy Fair. Today, the village is known as 'Old' Woking to distinguish it from Woking, which did not appear until the nineteenth century. The present houses also date from the twentieth century. The annual Charter Fair was revived in 1986 by the Old Woking Village Association, and for many years it was held during the May Bank Holiday weekend in the grounds of the White Hart public house in the High Street.

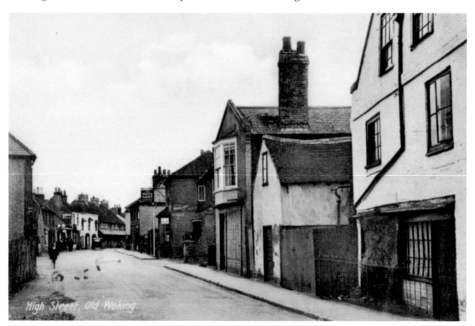

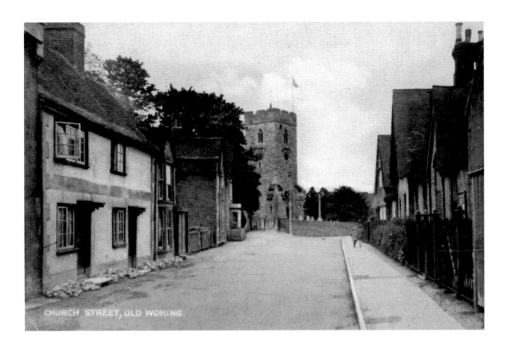

CHURCH STREET, OLD WOKING.

Church Street, Old Woking

Most of the buildings in the left of this picture have now disappeared, but others have replaced them. At one time there was a Market House on the corner of High Street and Church Street. It was probably built by Sir James Zouch in 1665. Until the early twentieth century it was used to store corn. In 1908, it was demolished and a row of cottages was built. Opposite the church is the church hall, and there is now a small car park opposite the church to accommodate worshippers. Most of the original houses have now been replaced.

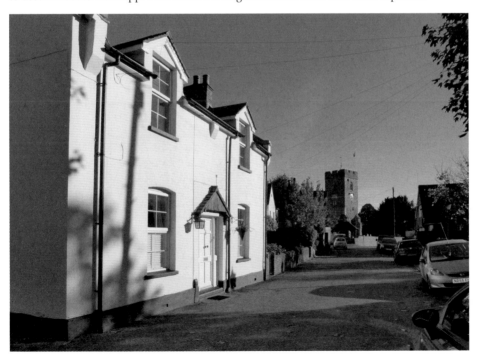

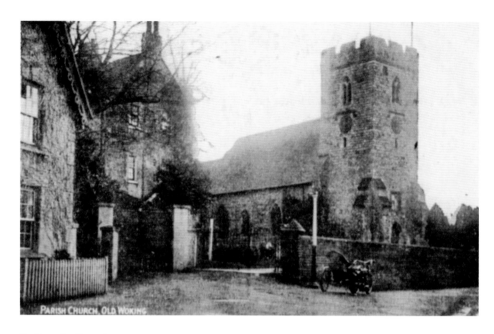

St Peter's Church

Built in the latter half of the eleventh century on the site of an earlier Saxon church, the Norman building still boasts the original oak door at the west end. Anglo-Saxon markings on it include an iron cross. In the thirteenth century, the church was enlarged and the south aisle added. Today the congregation still worships in a place that has been used for the same purpose for over a thousand years. At one time there was a three-deck hooded pulpit to allow those in the gallery to see the preacher. It was from this pulpit that Charles I listened to a three-hour sermon. The pulpit is still there but minus its top two layers!

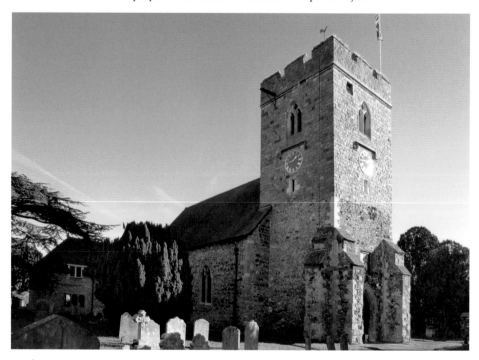

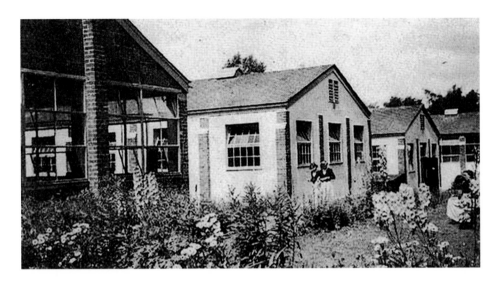

The Girls' Grammar School & the Park School

The First World War army huts in Park Road became the Girls' Grammar School in 1923. Later, more huts, connected by a covered walkway, were built to accommodate the growing needs of pupils. It was not until 1958 that a new girls' school was built on the corner of East Hill and Old Woking Road. The original site was renovated and eventually was reborn as The Park School, a school for boys and girls with learning difficulties. The area that was a 'sixth form lawn' is still there and a few years ago an air raid shelter was uncovered. The area around it has not changed as much as some other parts of Woking.

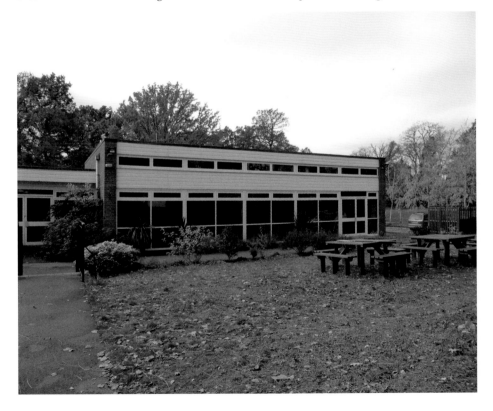

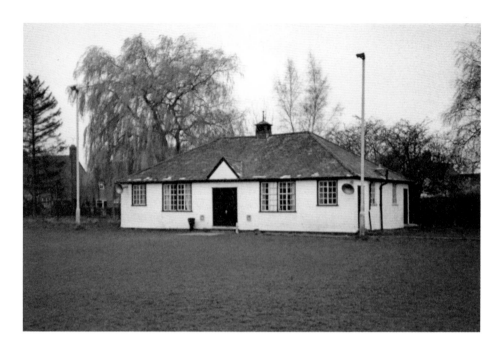

The Pavilion & Woking Football Club Training Ground

Although the Girls' Grammar School had tennis courts, it had no land for a playing field. Consequently, the pupils had to walk down to Kingfield Road to the playing field, where they played hockey in the winter and cricket in the summer. The photograph above shows the original pavilion. After the playing field was no longer used by the school, it played host to the Scouts and Sea Cadets. Then, in 2012, it reverted to its original use. The pavilion is no longer there but the large playing field is used as a training ground for Woking FC, whose premises are on the opposite side of the road.

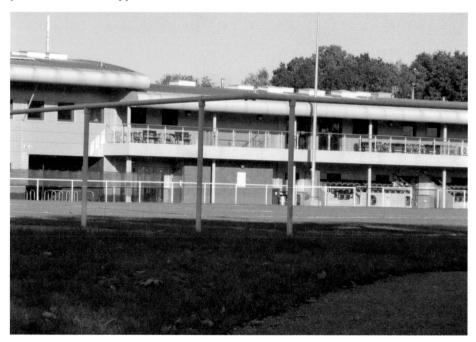

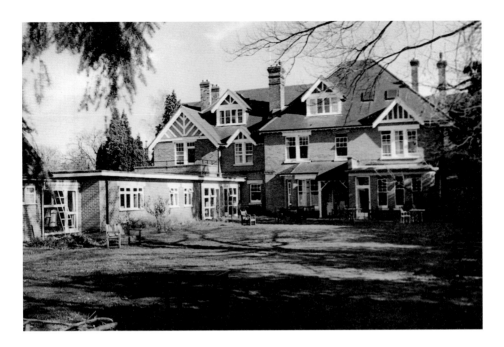

Marie Carlile House

Opened in the 1950s, this residential home was named after the sister of the founder of the Church Army, Wilson Carlile. It had been his own home and his sister Marie, who was in charge of the Church Army's sister work, also lived there. It functioned as a very successful care home for over forty years. However, at the beginning of the twenty-first century the Church Army decided, in spite of a great deal of local opposition, to close it and relocate the remaining residents. Flats now reside on the site. The name 'Marie Carlile' appears on the entrance.

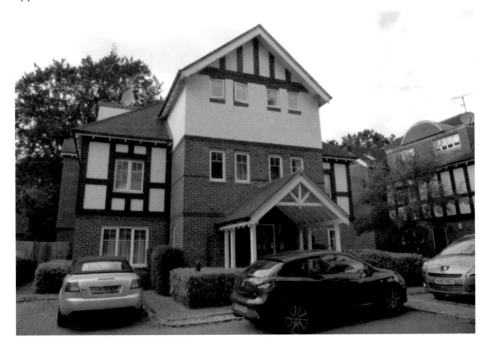

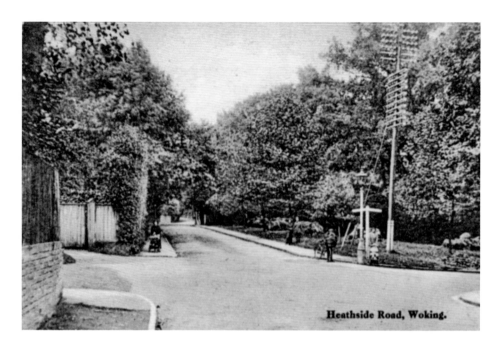

Heathside Road, Woking.

Heathside Road

Parts of Woking still retain much of their original rural character as developers have allowed many of the trees to remain. Heathside Road, at one time a mere track, was developed into a residential district in the late nineteenth century. Originally Heathside Lane, it became Heathside Road. Today, the community hospital and a doctor's surgery can be found on the southern side of the road. There is a large, fee-paying car park for the hospital. There is no fee for the doctor's surgery and the adjacent pharmacist, but visitors have to sign in with their car registration to avoid a fine!

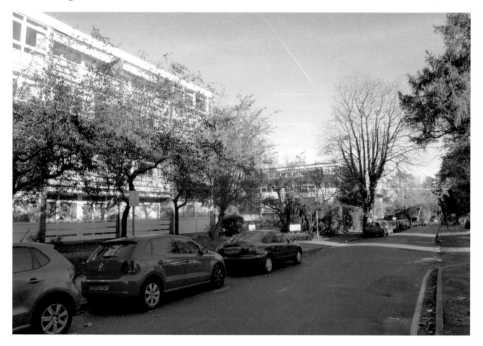

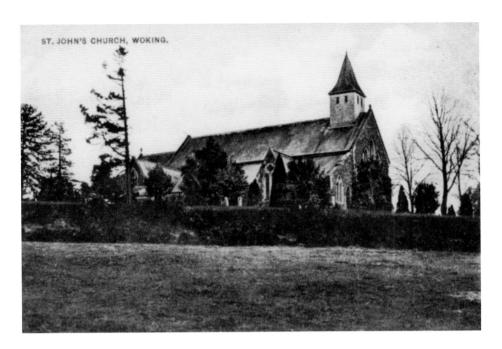

ST. JOHN'S CHURCH, WOKING.

St John's Church

In 1842, a small Chapel of Ease connected to the parish church of St Peter's was opened in the area known as St John's. Dedicated to St John the Baptist, it became a parish church in its own right in 1883. Today it is still a flourishing church serving the local community. Several services are held on Sundays and there are a variety of activities during the week.

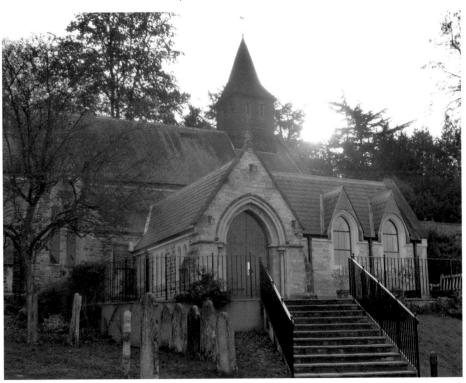

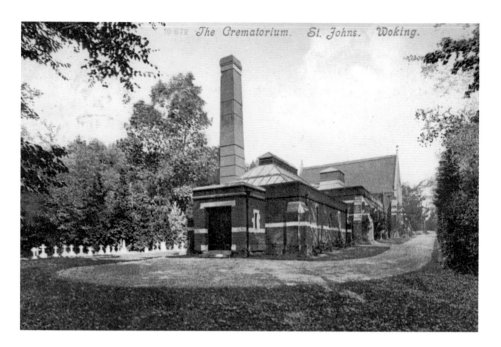

The Crematorium

In 1879, the first crematorium in England was built at St John's. The first cremation was that of a horse as an experiment. Cremation was still not legal at this time. It was not until 1885 that the first human cremation took place. There was still a great deal of local opposition, but by the end of the nineteenth century nearly 2,000 cremations had been recorded in St John's. Today the crematorium is very busy. There is some car parking but it is not always easy to find a space as there is no parking in the main road. On occasion, funerals have had to be delayed to wait for the mourners to park.

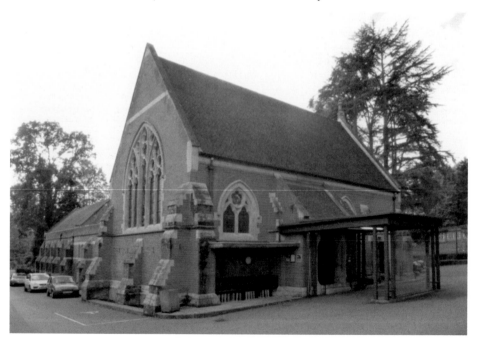

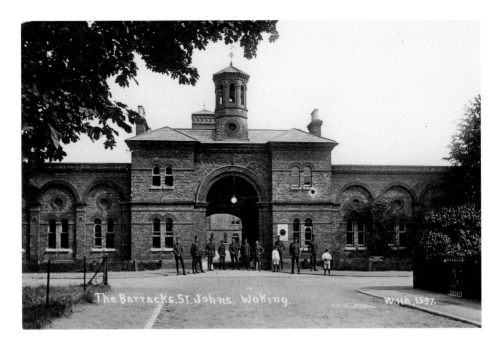

Inkerman Barracks

In the nineteenth century, there was no provision for prisoners who were seriously ill. To remedy this, a prison was opened in 1860 in Knaphill for male prisoners who needed medical care. In 1869, another building was erected for female prisoners. When both prisons later closed, the buildings were taken over by the army. Renamed 'Inkerman Barracks', they continued to be used by the army until 1965. Some of the buildings still remain in Inkerman Road but there is little evidence now that the Army were once in residence in the area. Inkerman Road is now a pleasant residential road.

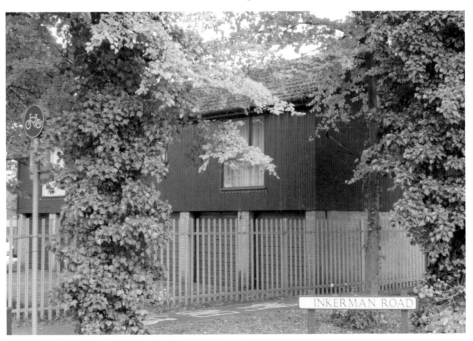

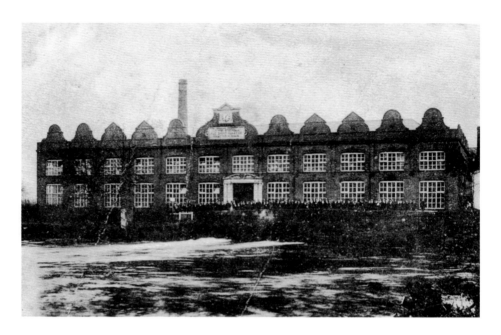

Unwin's Printing Works

A watermill, dating from Saxon times and recorded in the Domesday Book, became the site in 1896 of the Unwin Brothers' printing works after a fire had destroyed its original premises. The firm continued to flourish until the twenty-first century when it became part of Martins Printing Group (MPG). At one stage, the printing group that had been Unwin's was known as the Gresham Press. The author could not discover why the name was used but the flats that have replaced the printing works are known as Gresham Mill.

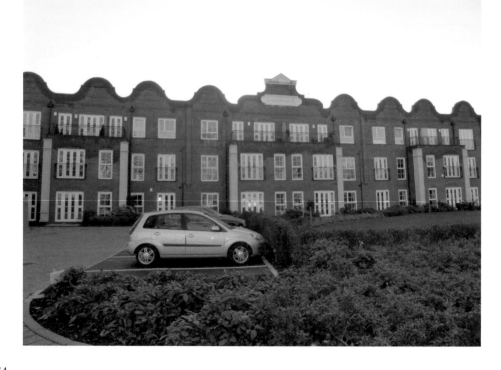

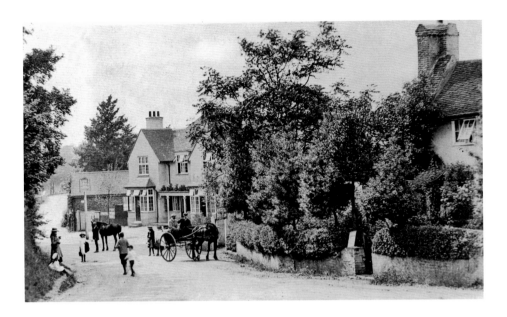

The Mayford Arms

In 1891, Vernon Robinson took over as licensee of the original Mayford Arms. In 1905, he had a new inn built on the site of a small cottage next door. When he died in 1941, his son took over, retiring in 1968. The present pub still serves the locality. The original Mayford Arms is now a private house known as Friars. Standing on the corner of Old Woking Road as it sweeps down to the roundabout to join the A320, the Mayford Arms still provides a traditional welcome to visitors. It provides a well-stocked bar, a varied menu and a roast on Sundays.

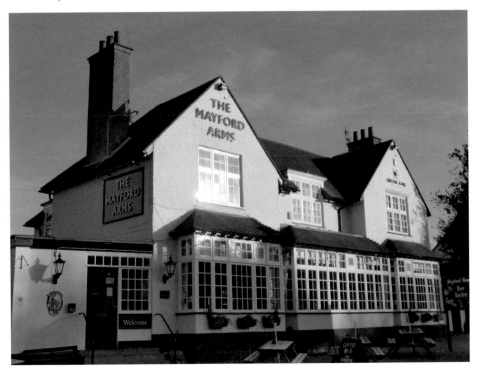

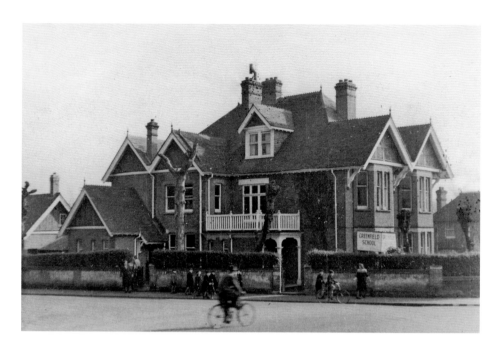

Greenfield School

In 1922, Denham House at the end of Constitution Hill became a Notre Dame School. In the 1930s, the school changed hands and was renamed Greenfield School. In 1948, it was taken over by Ruth Hicks and Joyce Pearce. In 1939, the former bought 'Beechlands' in Constitution Hill and this building is still used by Greenfield School today. Greenfield School continues to provide the high standards set by its predecessors. It now takes boys as well as girls. In 2013 there were 183 students – 114 boys and 69 girls. Pupils can enter the school at three years of age in the 'pre-prep' group and continue to eleven, when they go to a secondary school.

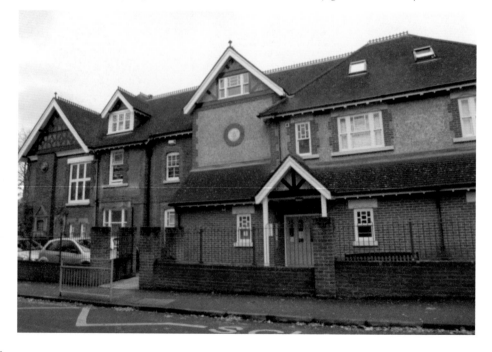

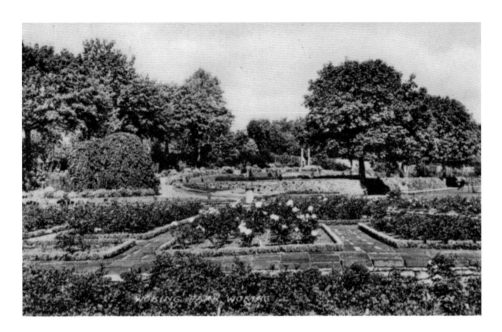

Woking Park

Between 1905 and 1911, a park was landscaped between White Rose Lane and Constitution Hill. It contained an immaculate bowling green, a cricket pitch with a pavilion, both grass and hard court tennis courts and a swimming pool. Sadly, towards the end of the twentieth century, it started to deteriorate and some of its facilities disappeared. Today, the park has been restored to its former glory and is even more impressive than it was. There is a huge leisure centre, a playground for children, several hard tennis courts, a cricket pitch, a bowling green and an impressive new swimming pool. As well as catering for the energetic, there are pathways and seats where visitors can sit and enjoy the manicured flower beds and trees.

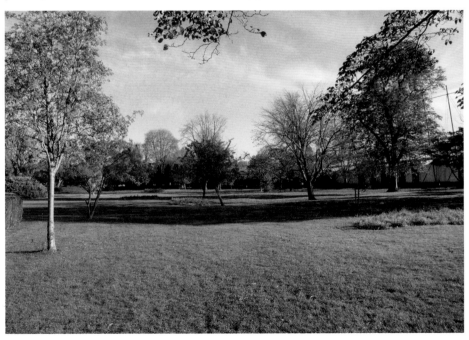

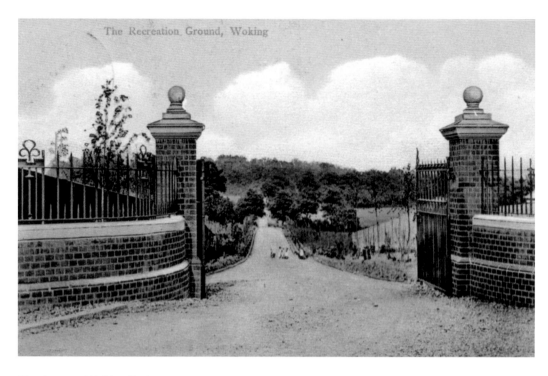

The Recreation Ground, Woking

The Avenue, Woking Park

The impressive entrance to the park is situated on Constitution Hill and a tree-lined path leads to the tennis courts and the pristine bowling green. The entrance has been restored and visitors can wander down, absorbing the beauty of nature before indulging in a game of tennis or bowls.

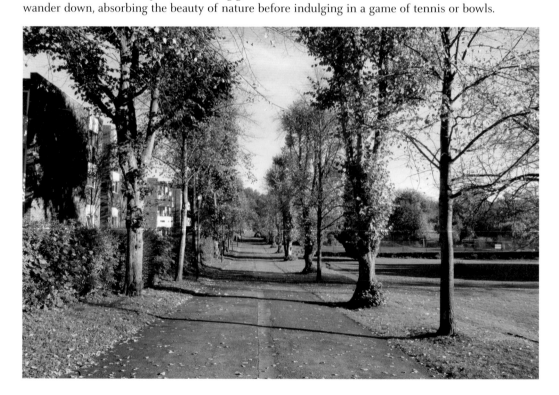

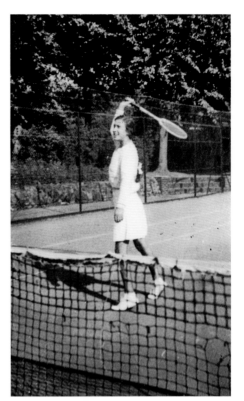

Tennis in the Park

The public tennis courts were in frequent use
during the 1950s. The two hard courts were
approached at the end of the Avenue. The grass
courts were at the other end of the park near the
cricket pitch and pavilion. A booking system was
in operation. The two hard courts at the end of
the Avenue have been restored to their former
glory on the same site. Maintaining grass courts
is never easy and these have been replaced
with three hard courts, which are often used for
matches, as in the photograph below.

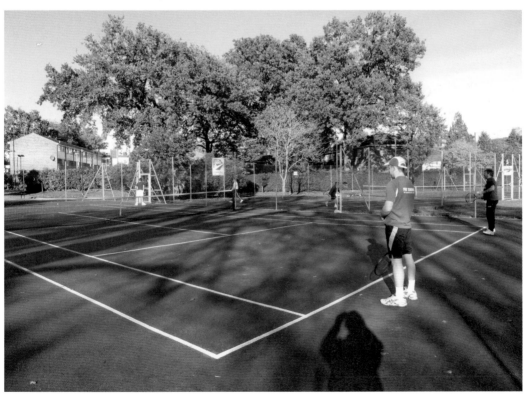

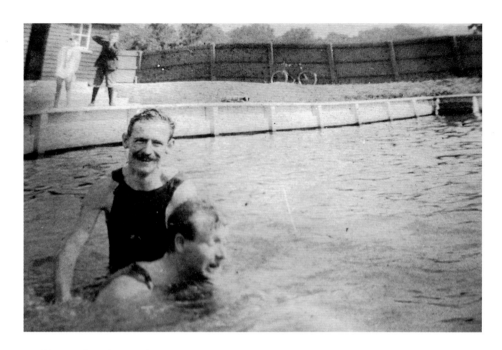

Woking Swimming Pool

In 1910, a primitive swimming pool was opened near the Hoe Stream, which supplied its water. As the nearby area was a refuse dump, its site was not ideal and, in 1935, it was replaced by a new, open-air swimming pool built in the fashionable lido-style. Today, this has been replaced by the modern Pool in the Park, which is enclosed in glass. Its warm atmosphere is a welcome contrast to the icy waters of previous years. A competition was held to produce a name for the new pool and it was won by a local primary school girl. (*Photograph above: copyright of Surrey History Centre*)

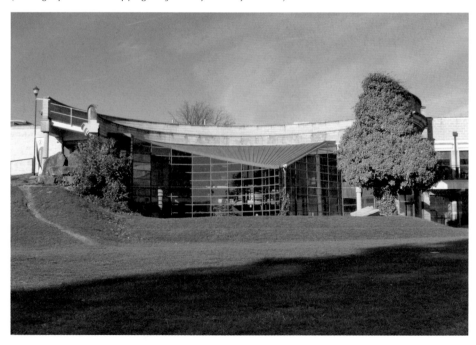

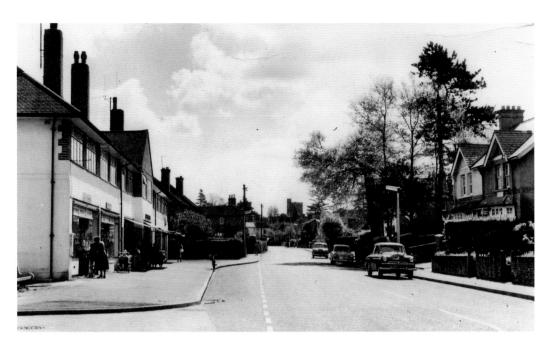

Horsell High Street

Originally common land where cattle grazed, Horsell changed in the mid-nineteenth century. A nursery was opened on part of the present High Street. However, this closed in 1938 when houses were built. The village hall was built in 1907. Today, shops are to be found on either side of Horsell High Street. The village hall has been refurbished and is used by local drama and dance groups for rehearsals. For many years, Horsell Amateur Dramatic Society, the oldest of its kind in Surrey, performed plays there twice a year. When the Rhoda McGaw Theatre opened its doors, the plays were transferred to the new theatre but the village hall is still used for rehearsals. (*Photograph above: courtesy of David Rose*)

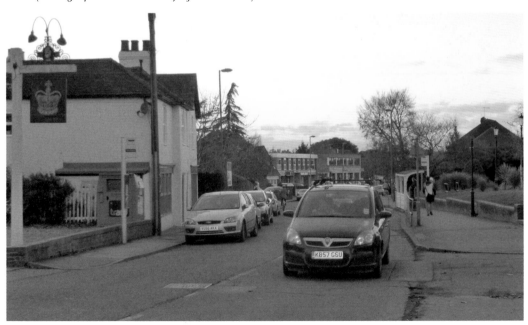

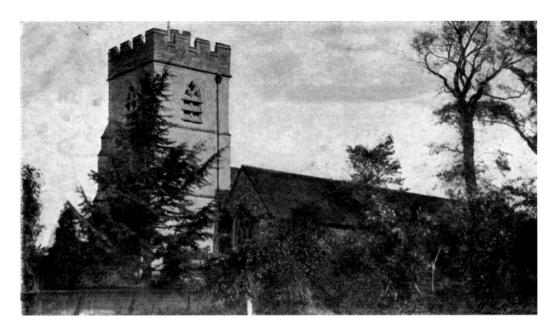

St Mary the Virgin Church

It is likely that a stone chapel was originally built in the twelfth century on the site of the present St Mary's church. In the fourteenth century it was rebuilt and, during the following century, the south aisle was added. Today, the church has a large congregation and continues to serve the local community as it has done for many centuries. It provides services for children and young people, as well as the more senior among its congregation.

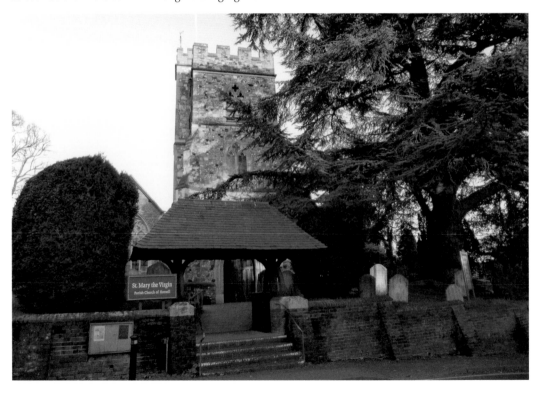

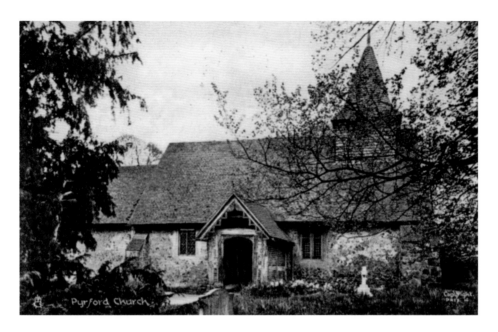

Pyrford Church

St Nicholas Church, Pyrford

The name 'Pyrford' first appeared in a record in AD 698. It means 'the ford by a pear tree'. In the eleventh century, the manors of Pyrford and Horsell were held jointly by the King. The church of St Nicholas was built in the twelfth century. When it was restored during the nineteenth century, some interesting Norman wall paintings were discovered and can still be seen today. The church, perched on a hill and surrounded by a well-tended graveyard, continues to serve its parishioners as it has for over a thousand years. In the twentieth century, another modern church, the Church of the Good Shepherd, was built nearer to the village.

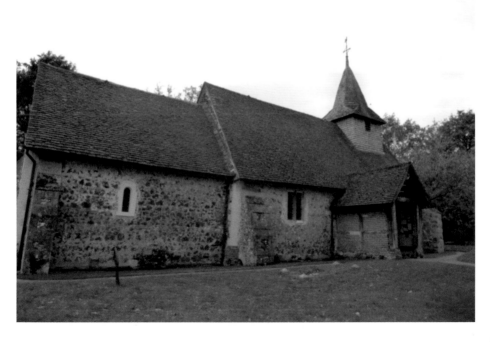

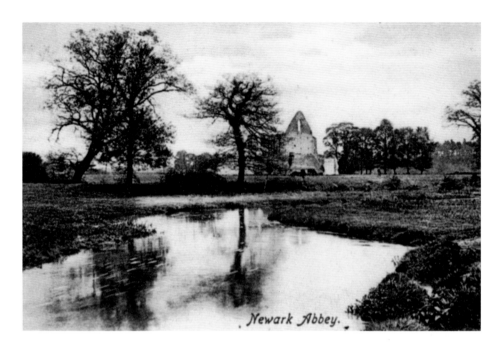

Newark Abbey.

Newark Abbey

Newark Abbey, near Pyrford, was founded at the end of the twelfth century. It was run by the monks who had originally worshipped in 'Old' Woking. The abbey continued to function until 1538, when it fell prey to Henry VIII's Dissolution of the Monasteries. Newark Abbey is still a striking landmark on the winding road to Pyrford. The ruins still stand in the middle of a field that belongs to a local farmer, so they can only be viewed from a distance. However, a sunrise service, usually led by the vicar of the Church of the Good Shepherd, is held there every Easter.

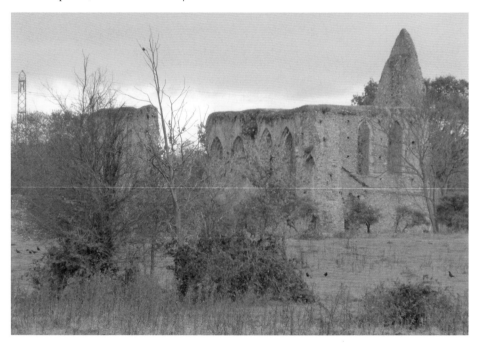

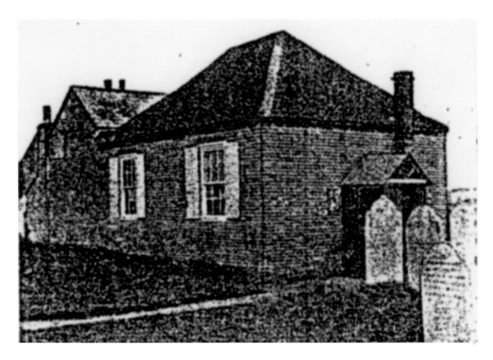

Horsell Common Chapel

In 1815, a chapel was built on the edge of Horsell Common. It was used by a Baptist group and the building was renovated in 1907. A small graveyard surrounded it. In 1963, the chapel was sold to Mr Sydney Fleet, who belonged to a Brethren group. This group used it for worship until the 1980s, when it was demolished. Mr Fleet's son, Andrew, built a house, appropriately named Chapel Corner, on the site. The bodies were left in situ and were not built over. Permission was obtained for the gravestones to be moved and these were used to pave the path leading to the front door. (*Photograph above: courtesy of David Rose*)

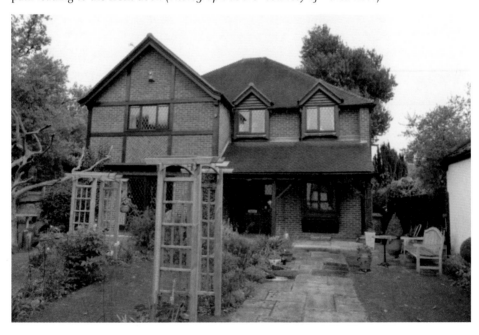

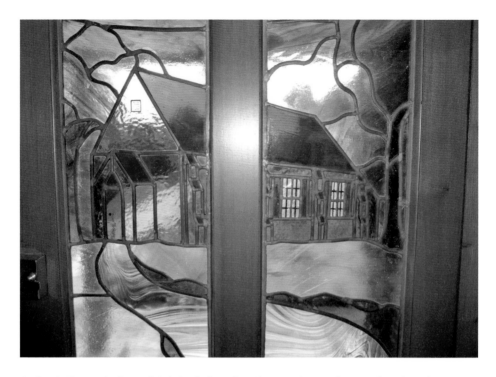

Stained-Glass Window of Original Chapel and Mr and Mrs Fleet at the Chapel
When the chapel was demolished, many felt that is was important to remember it. The front door of Chapel Corner has a stained-glass representation of the original chapel. Andrew Fleet and his wife still live in the house. Mr and Mrs Fleet, who bought the Horsell Common chapel in 1963, pose in front of the entrance to the chapel. Mrs Fleet died in 1983 and Mr Fleet was sadly killed in a car crash in 1986.

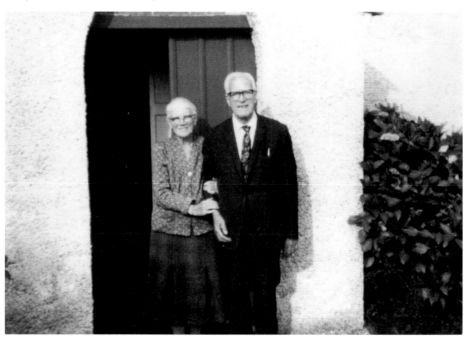

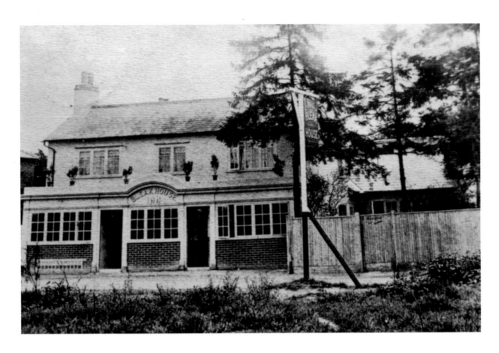

Bleak House

The name of this public house, situated on the Chertsey Road leading to the M25, has nothing to do with Charles Dickens' book of the same name! When it was built in the late nineteenth century, it was surrounded by open common land, which was very 'bleak'. For many years, the pub continued to be called Bleak House. Its surroundings have changed considerably since its beginnings and it now sits beside a busy road. In 2004, the pub was sold by the brewery, who owned it, to a couple who renamed it Sands as a reminder of the sandpits in Horsell Common.

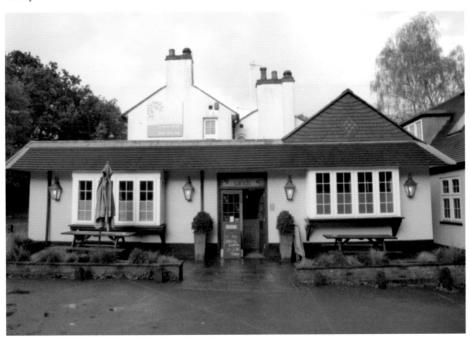

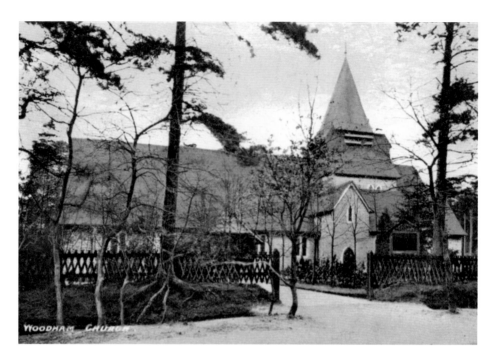

All Saints' Church, Woodham

The foundation stone of All Saints' church in Woodham Lane was laid in 1893, and it was partly completed in 1894. In 1902, it became a parish in its own right. It was not until 1907 that the church was finally completed. Today it still serves the local residents as the parish church. A daughter church, St Michael's in Sheerwater, for a while shared its premises with the Methodist church, which had no building in the area.

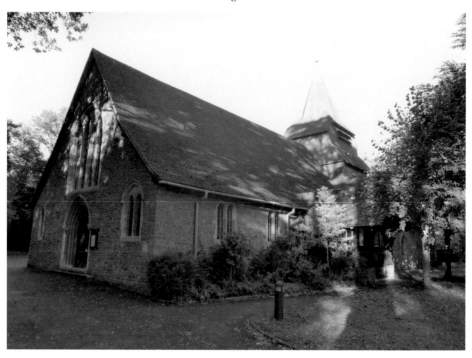

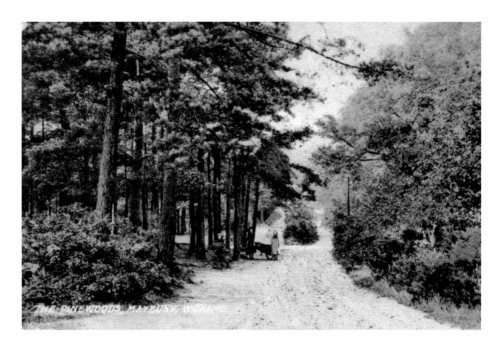

The Pines

Among the many trees that grace Woking are a great number of ancient pine trees. It is not known when they were introduced but paths through the woods allow walkers to forget the stress of modern living and relax. Woking is still surrounded by a green belt area and, although only 25 miles from London, it still retains much of its rural character. There are tree-lined roads and deserted wooded areas within walking distance of the town centre. The picture below is of the silver birches in Pyrford Common, which has a playing field and is a popular place for picnics.

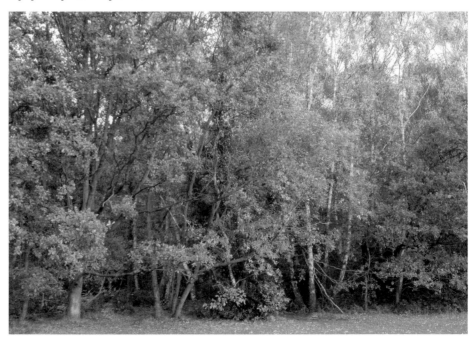

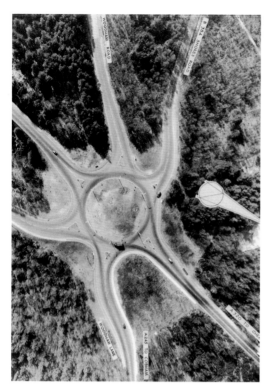

Six Crossroads Roundabout
It was in the 1930s that Woking Urban District Council started to formulate a traffic plan for the town. The junction of the six roads at Maybury was becoming a hazard for the increasing volume of traffic, so a roundabout was planned. However, it was not until 1963 that this roundabout was completed, and it was several years later that a board finally named it Six Crossroads. (*Photograph above: courtesy of David Rose*)

Woodham Lane

In 1932, Woodham Hall and its 67 acres were sold. The hall was demolished and the area was developed for new housing. A number of detached houses were built and the main road became Woodham Lane. South of this, three smaller roads, The Riding, The Gateway and Woodham Waye, were established. Today, Woodham Lane is a busy tree-lined road, one of the six crossroads leading to West Byfleet, New Haw and Addlestone. (*Photograph above: courtesy of David Rose*)

Brewery Road

Hops had been grown in Woking for some time and in 1715 a brewery was founded at the bottom of Church Hill using only hops and barley grown locally. The brewery, under several owners, flourished until the early twentieth century when it closed down. All that remains today of the brewery are the names 'Brewery Road' and 'Malt Way'. However, the road now has another claim to fame. For many months, the car park and the bridge over the canal were out of use. Today the impressive Living Planet Centre has been built over a new car park and, to the great relief of residents, the bridge is again open. The centre should be open to the public in 2014.

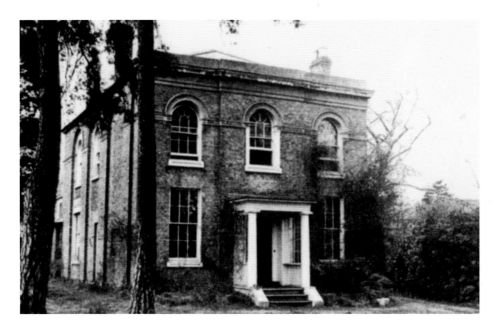

Alwyne House and Trinity Methodist Church

Built at the junction of Brewery Road and Chobham Road in the late 1850s, Alwyne House was one of the new, luxurious gentlemen's residences. It was inhabited by the Spencer Compton family until 1927, when it was sold. It continued as a residence until the 1960s when it was demolished. The Methodist church had several venues in Woking over the years, but it was not until the latter part of the twentieth century that Trinity Methodist church was built at the corner of Brewery Road and Chobham Road on the site of Alwyne House.

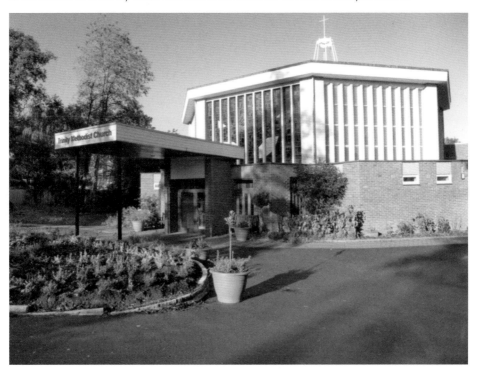

The Factory, Rose Cottage Laundry

Rose Cottage Laundry on Horsell Moor was founded in 1904 by Mr Edgar Ashley Cook, a former chairman of Woking Council. This small family firm employed mainly women, who would often start working there straight after leaving school. The laundry later used the name of the founder. In 1971, the company was taken over by Tomlin's but retained the name of Ashley Cook. Today the laundry still functions on the same site but under the name of White Knight. There was also a White Knight laundry in the High Street in Woking. It is identified in the mural by the embankment.

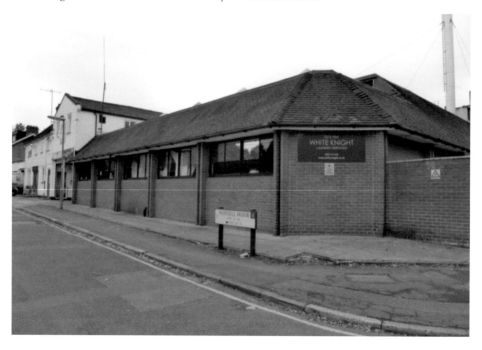

Acknowledgements

The following photographs are reproduced by permission of Surrey History Centre: page 7 top, page 8 top, page 14 top, page 35 top, page 80 top, page 87 top.

The following photographs were contributed by David Rose: page 11 top, page 19 top, page 21 top, page 22 top. page 23 top, page 24 top, page 27 top, page 29 top, page 34 top, page 37 top, page 41 top. page 46 top, page 81 top, page 89 top, page 91 top, page 96.

Other photographs have been provided by Philip Moll (Mayford Arms), Rosemary and Richard Christophers (library, trains and Mayford Arms), Terry Gough (railway and trains), Linda Richardson (Greenfield School), John Craig (Alwyne House), Margaret Etheridge (Marie Carlile), Shirley and Denis Parker (Woking Girls' Grammar School and street scenes), Paul Martin (Managing Director, Hugh Harris), Lee Simpson, (Director, Hugh Harris), Mr M. K. Maugham (Courtenay Free Church), Christine Herne (Woking Homes), Jane Hawkins (street scenes and buildings), and Andrew Fleet (Horsell Common Chapel).

Most of the modern-day photographs were provided by the author.

I would like to thank all the above for their help in compiling this photographic record.

About the Author

Marion Field grew up in Woking, went abroad to teach and returned to the town to take up a position as Head of English in a comprehensive school. She has seen many changes in the town and is fascinated by the way in which it has developed. She took early retirement to concentrate on writing and has had fifteen books published. As well as local history, she has written several biographies and also books on the English language. In her spare time, she enjoys acting with a local dramatic group, playing tennis, reading and travelling. She is also an active member of her local Anglican church.

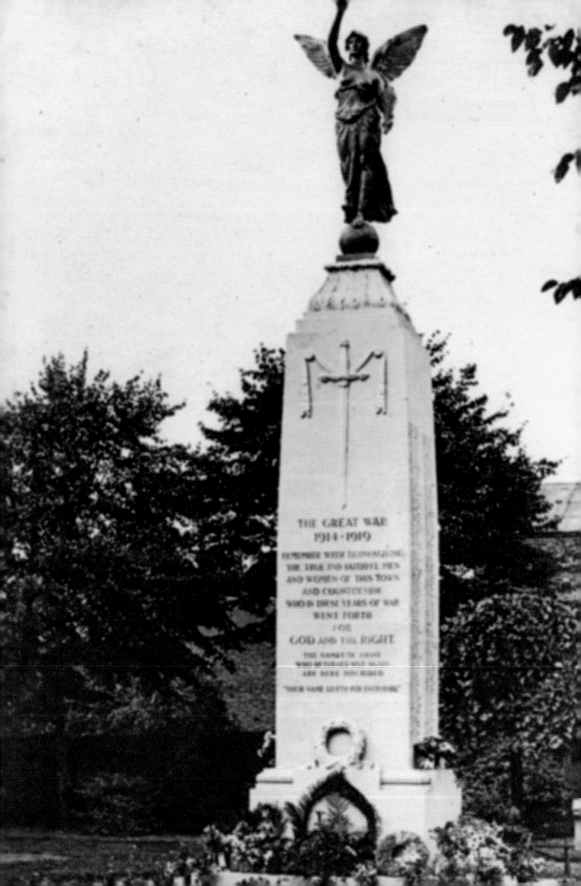